ARTIST'S HANDBOOK:

ACRYLICS & GOUACHE

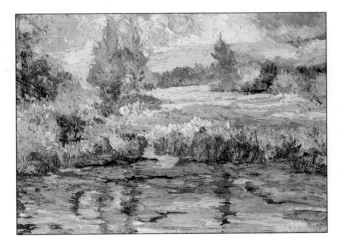

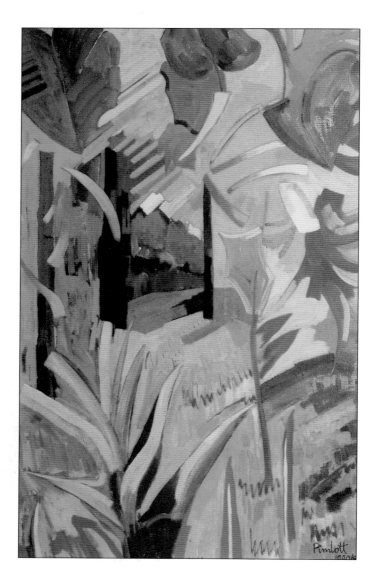

Pimlott
1990

ARTIST'S HANDBOOK:
ACRYLICS &
GOUACHE

materials • techniques • color and
composition • style • subject

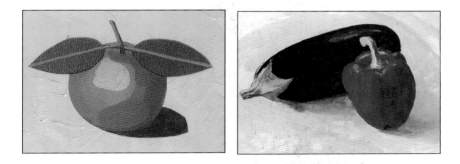

Contents

Introduction

For those who are new to acrylic painting
there could be no better medium. You can
do virtually anything with acrylics, which is
why they are favored by artists who like to
experiment.

Acrylics are water-based and odor-free,
which is a bonus when you work at home.
Some people are discouraged from using
oil paints because of the pervasive and
lingering smell, and a few are allergic to oil-
paint solvents such as turpentine and
mineral spirits. Acrylics also dry fast, so you
will not encounter the oil painter's difficulty
of carrying wet pictures home from an
outdoor painting session.

Gouache is similar to watercolor in that it
is bound in gum arabic and is soluble in
water. It is characterized by a rich, matte,
opaque surface that lacks the transparency
of watercolor and the gloss of oil paint. It is
a fine medium for architectural subjects, or
for figures in interiors, since it lends itself to
fine detail.

The Medium

ACRYLICS IN THE MAKING

Acrylic paint is made by mixing powdered pigment with acrylic adhesive. The adhesive looks milky when wet but becomes transparent when dry, revealing the true color of the pigment. In factories where the paint is made, you can see the enormous vats of this raw, jellylike substance before the enhancing color is added being wheeled to and from the mills and mixing machines that eventually produce the finished paint.

All the ingredients are carefully weighed and tested before use. It is this painstaking precision and control during manufacturing that enables thousands of tubes of paint of almost identical color, consistency, and quality to be turned out at any time.

The pigment is brought in vast quantities from all over the world. Some colors, such as the siennas and umbers, are dug out of the ground; others, like cobalt blue, are mineral pigments; and some pigments come from plants and animals. But many colors, such as napthol crimson and diozine purple, are created in the laboratory by scientists and are as new to the world of art as acrylics are themselves.

Pigments, often strikingly beautiful in their raw state, come to the factory as powder. As with the other raw materials, each color is scrutinized and tested before being used in the paint.

Not all the pigments used by painters of the past are suitable today

Acrylic paint is mixed thoroughly in large quantities to obtain the consistent color and quality necessary for artists.

for making acrylics. Some of the traditional ones, such as alizarin crimson, are incompatible with the synthetic resin and tend to coagulate or thicken. In such cases, an alternative organic pigment, one which can be mixed with the resin, is used instead.

There are other pigments that will not mix quite as densely with the resin as would be ideal. Cadmium red and cerulean blue are two such pigments, and in both cases the acrylic colors are weaker and less saturated than their oil counterparts.

Acrylic enjoys a reputation as the most hardwearing and weather resistant of all artists' paints — a reputation that depends on certain essential ingredients. The mixture of resin and pigment includes a preservative to prevent deterioration; an antifreeze to stop the tubes from freezing up in cold weather; a thickening material to give the acrylic a consistency similar to that of oil paint; and, finally, a wetting agent to stabilize the paint and disperse the pigment evenly in the resin.

To obtain the extremely fine texture of the finished paint, the ingredients are ground thoroughly in special mills. This is unlike oil paint, which is traditionally ground between heavy granite rollers. Suitable "hi-tech" steel that is used in the manufacturing stages disappears as the water evaporates, leaving the plastic coating as clear as any truly transparent plastic, such as Lucite.

Consequently, an almost ideal paint is made. This coating of each tiny particle of pigment with a practically indestructible layer of transparent plastic gives us pure color that will not rot, discolor, or crack and has few of the faults and drawbacks found in more traditional artists' colors.

HOW ACRYLIC PAINT IS MADE

 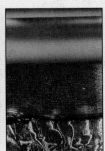 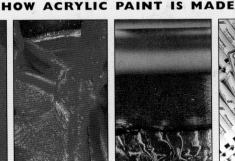

The first constituent is the powdered pigment.

The pigment is mixed with acrylic adhesive.

The paint is then milled between steel rollers.

After it has been inspected, the paint is put into tubes.

PIGMENTS

As explained on page 8, pigments are the coloring materials of paint, and are usually made in the form of powders. From the earliest, pigments had to be bright and clear, and able to withstand prolonged exposure to light. Certain colors were apt to fade and did not produce the subtle tints and shades we admire today, but were more likely to produce a dead or muddy effect.

Throughout history, bright color was preferred for both practical and aesthetic reasons, having close associations with joy, celebration, pleasure, and delight. To express these emotions, bright, rich hues were in constant demand, and the search for pigments that possessed these qualities has been constant over the centuries.

By the Middle Ages, the range of colors was quite extensive, and put to complicated use on walls, in illumination panels, in books, and on woodwork. An all-purpose paint like acrylic would have suited them admirably.

After the Renaissance, pigments reached a peak of brightness and variety. Thereafter, a more expressive and realistic style emerged—the medium more suited to this was oil paint. Realistic paintings moved away from bright colors to rich, somber hues, which brought a new range of pigments into being. An interest in brighter color returned again in the 19th century due, in part, to the artists Constable and Turner, the designs of William Morris, and the Impressionists.

Delight in bright color today means a wide range of pigments, and the list of those available is long. The names of pigments often echo places: burnt Sienna, Venetian red, Naples yellow, Prussian blue, Chinese vermilion; or recall the materials they are derived from: cobalt blue, rose madder, emerald green, ivory black, sap green, geranium lake, and so on. Though interesting sounding, the names give little indication of the quality or behavior of colors, and some are sold under two or three different names.

Briefly, the requirements for a reliable pigment are that it should be smooth, finely divided powder; insoluble in the medium in which it is used; able to withstand the action of light without changing color under normal exposure; and chemically inert and unaffected by materials with which it is mixed or by the atmosphere. Moreover, it should possess the proper degree of opacity or transparency to suit the purpose for which it is intended, and should conform to accepted standards of color and color quality.

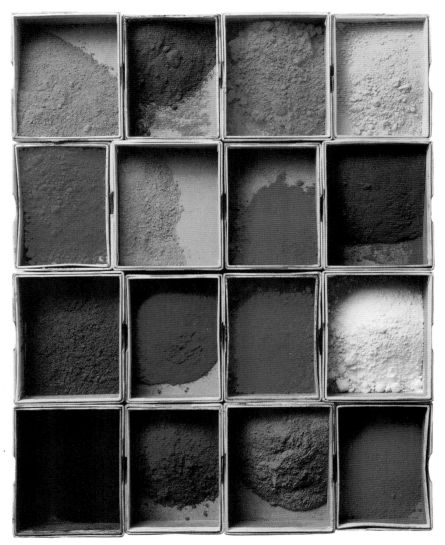

When pigments are seen as powders, they are fresh and bright with a beauty all their own. When mixed with a small quantity of water, a paste is formed that can be used for painting. When the water dries, the bloom returns, but so does the powder. In other words, it reverts to its former state. What is needed is something to bind the colored grains together to make them adhere. For this purpose some kind of glue or binder must be added to the powder before it actually becomes paint.

The History

ACRYLICS

An American firm, Rohm and Haas, first started to experiment with synthetic resin in the 1920s. The following decade saw it being used for small items such as false teeth and the heels of shoes.

These early acrylics, or polymers, were eventually developed as a base for house paints. Such house paints were found in pastel colors only because the resin emulsions used at that time could not absorb much pigment without solidifying. This form of paint was therefore of little use to the artist. Yet it was becoming more and more necessary to find a resin that would provide a suitable base for acrylic color for painters, one that would not crack or discolor and was, above all, resistant to weather and atmospheric extremes.

As far back as the 1920s a group of mural painters in Latin America,

BELOW: SPAWN by Morris Louis (b.1912). *Louis, one of the first artists to experiment with acrylics, was painting with the new medium as early as the 1940s. In this painting, the diluted color was applied directly onto unprimed canvas, producing the "stained" effect that is now synonymous with his work.*

mainly Mexico, planned large murals for public buildings. These artists, notably David Alfaro Siqueiros (1896–1974), José Orozco (1883–1949), and Diego Rivera (1886–1957), were acutely aware of the inability of oil paints and frescos to stand up to outdoor weather conditions and were eager to help any research that would solve their problem. They realized that their solution lay in synthetic resin, already being used in industry with success, and by the mid-1930s Siqueiros's workshop in New York was experimenting with new paint formulas. Artists and scientists worked together to further mutual interests, and so acrylic painting was born.

It was not, however, until World War II that manufacturers of artists' materials began to put their minds seriously to making a paint based on the new resin. The first company to make a form of acrylic paint with enough saturated color to be useful in the design field was the American firm "Permanent Pigments." Their product was called Liquitex, a resin emulsion of the same consistency as poster color. This product was welcomed by designers, and its reputation quickly spread to the fine arts.

The initial problems of hardening that occurred when the resin was mixed with too much pigment did not vanish overnight. In these early days, many companies ran into great difficulties when they first started to produce new paint, and the slightest overloading of a pigment would quickly cause the paint to become unusable.

By the 1950s, acrylic paints were on sale in the United States and warmly welcomed by many young painters who were eager to experiment with this new medium, notably the many abstract and Pop artists working at that time. By the 1960s, the new colors were also available and widely used in Europe.

GOUACHE

Historically, gouache was used primarily for manuscripts, although in the seventeenth century it became more widely used as a medium for painting by Italian and Dutch artists, including Zuccarelli and Van Dyck. In the eighteenth century, Paul Sandby used both watercolor and gouache extensively. Toulouse Lautrec produced some of his finest café paintings using gouache on scraps of brown paper and cardboard. Edouard Vuillard painted his evocative, atmospheric interiors using a dry-brush technique. Among contemporary artists, the gouache paintings by Keith Vaughan, Ceri Richards, and Graham Sutherland are outstanding.

Gouache is a very adaptable medium with a wide range of colors available. The color can be used thickly or it may be watered down to a fine wash.

Materials

The equipment for painting with acrylics is not complicated. All you actually need are a few tubes of paint, a brush, something to paint on, and a jar of water. You will probably, however, soon find this selection limited and will want to extend your choice of materials as you become more proficient in the medium.

This next section covers the whole range of tools and materials available for acrylic and gouache painting, but we are not suggesting that you should rush out and buy every item before starting work. It is far better to begin with a few essential pieces of equipment and a limited range of colors, adding more to these gradually as you gain experience and increased confidence, than to make a large and often unnecessary investment during the early stages.

Paints and Colors

A selection of the basic colors, not necessarily more than 15, can provide a wide range of colors and tones. Winsor and Newton's Liquitex and Aqua-Tec encompass a wide choice, as does Rowney's Cryla. Although PVA colors are cheaper, they lack permanence. A basic palette would include black, white, lemon yellow, yellow ochre, raw sienna, Venetian

Acrylic tube and pot paints

red, cadmium red, deep violet, cerulean blue, cobalt blue, ultramarine, Hooker's green, monestial green, and bright green. As a result of laboratory research, new colors such as phthalocyanine green and dioxazine purple are available as well as the traditional colors. The nozzle of the tube of paint must be cleaned after use and before replacing the cap to prevent air from penetrating and solidifying the contents.

Gouache colors, available from Rowney, can be mixed with acrylic medium on the palette, allowing layers of paint to be laid over each other without the color underneath being affected—which ordinary gouache will not do.

Acrylic paints are a by-product of the plastics industry, just like the emulsion paint we use on our walls. They are also an emulsion. All paints are made with pigments—that is, the actual colors, which may be natural or chemically synthesized—and so are acrylics. The pigments used for acrylics, with a few exceptions, are the same as those used for oils, watercolors, and pastels; what makes them different is the binder (see pages 18–19).

Because the paints are water-based, they are thinned by mixing with water, not with oil. They don't, of course, have to be thinned at all—they can be used straight from the tube or jar, or even made considerably thicker by mixing with one of the many mediums specially made for the purpose. With acrylics, you can paint in any consistency you like, which gives acrylic paints what is perhaps their greatest virtue: their amazing versatility.

You can use acrylics in thin washes resembling watercolor, or put on colors with a knife in thick slabs. You can use them thick in one part of a picture and thin in another; you can build up an infinite variety of textures; and you can employ traditional glazing techniques—much easier in acrylic than in oil. They are equally suited to large-scale paintings and small, delicate flower studies or miniatures. They can be used outdoors or in, and combined with other painting and drawing media in mixed-media and collage techniques.

Their only possible disadvantage is that they dry very fast. This can be helpful, because it allows you to overpaint without waiting long for an earlier layer of color to dry, but it does make it more

difficult to move paint around on the surface or to blend colors. However, the manufacturers of artists' paints, ever alert to possible shortcomings, have now produced mediums to slow drying time, so the problem has largely been solved.

Gouache colors

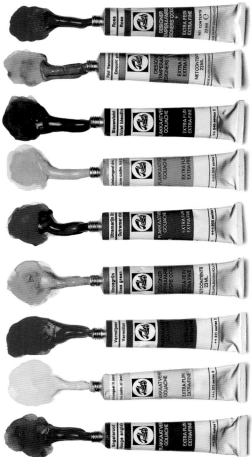

Acrylic Mediums

As you become better acquainted with various techniques and styles of painting, you will discover the value of working with mediums. These are substances that are added to acrylic paints to make them more versatile and adapt them to the job at hand. They can smooth, protect, alter the surface texture, or extend the drying time. There is a wide variety to choose from, and most of the major paint manufacturers produce them. Be sure to read the manufacturer's instructions before use.

Because acrylic is water-based, you can thin it by adding more water. This is the only medium you need for early experiments. But there are several mediums made especially for acrylic work that you may find useful later on. They change the nature of the paint in various ways, making it slower to dry, more transparent, or thicker. Based on the polymer emulsion used in the manufacture of the paint, the mediums are white when applied but become transparent when dry.

The packaging varies from tubes to tubs and bottles, but the brands are much the same. However, only one or two manufacturers make mediums for special textures, so you may need to seek these out.

VARNISHES
Acrylic varnishes are made in matte and gloss versions. Their main function is to protect work from discoloration caused by dust and other pollutants. It is wise to varnish a painting that is to be hung and framed without glass.

GLOSS MEDIUM: *Used mainly for glazing methods. It makes tube colors thinner and more transparent so that they can be built up in successive layers.*

MATTE MEDIUM: *Similar to gloss medium, but thicker, because it contains a waxy substance to reduce shine. Use it for glazing if you want a matte surface.*

GEL MEDIUM: *A jellylike form of gloss medium, which thickens the paint for impasto effects. It does not affect the translucency of the colors.*

TEXTURE PASTE: *Also known as modeling paste. A very thick medium for heavy impastos and special texture effects.*

RETARDING MEDIUM: *Used by artists who like to achieve oil-painting effects, this slows the drying time, so that colors can be blended.*

FLOW IMPROVER: *Also known as flow enhancer, this is a solution of wetting agents that helps to break down the gel structure of acrylics.*

CLEAR GLAZING MEDIUM

You can achieve watercolorlike effects or lay transparent glazes simply by thinning the paint with water, but the special glazing mediums (acrylic, matte, gloss, and gel) make the paint more lustrous as well as more transparent. They will even impart a translucent quality to thick or medium-consistency opaque paint—which water will not do—and they give the paint more body, so that it stays in place rather than run down the surface.

This medium has a number of uses. For the beginner, it serves as a handy protection device. For example, if you are worried about spoiling a part of the painting that you have already applied when you still have more to do, an application of clear glazing medium offers some protection. You can go on without damaging the work underneath.

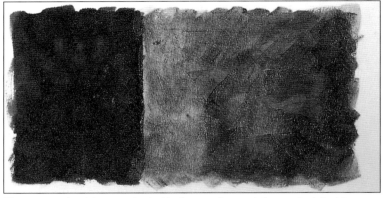

The paint on the right was mixed with gloss medium, and that on the left with water alone.

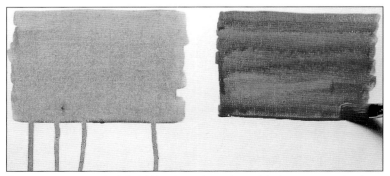

The watery paint on the left dribbles down the surface, while the paint mixed with matte medium remains in place.

Brushes and Knives

To some extent, your choice of brushes will be dictated by the size of your work and whether you like to apply the paint thickly or thinly. The bristle brushes used by oil painters and the soft brushes made for watercolors are suitable for acrylics, but avoid expensive sable brushes, which could be spoiled by constant immersion in water.

The major manufacturers produce synthetic brushes designed especially for acrylic painting. These are tougher and springier than the synthetics made for watercolors. They are an ideal choice for beginners, because they are durable, keep their shape well, and are suitable for both thin and thick methods.

Bright Flat ferrule, short-length hairs, usually set in a long handle. Useful for short, controlled strokes and with thick or heavy color.

From left to right: red sable round, Russian sable bright, red sable bright, red sable fan

Fan Flat ferrule, spread hairs. Natural hair is more suitable for soft blending and synthetic works well for textural effects. Useful for smoothing and blending, special effects, and textures.

Filbert Fuller in shape than flats, with slightly rounded ends that make soft, tapered strokes.

Fitch Straight edges and chiseled sides set in a round ferrule. Long handles. Used for applying lots of color and is effective on textured surfaces.

Flats These have long bristles with square ends. They hold a lot of paint and can be used for bold, sweeping strokes, or on edge for fine lines.

Hake An oriental-style wash brush on a long flat handle. Useful for laying in large areas of water or color.

Mop A round, full version of the wash brush, made of soft, absorbent natural hair. Useful for laying in large areas of water or color, for wetting the surface, and for absorbing excess media.

Oval wash Wash brushes come in varied shapes. The oval wash has rounded hairs, flat ferrules, and produces a soft edge with no point. Useful for laying in large areas of water or color, for wetting the surface, and for absorbing excess media.

Round Round ferrule, round or pointed tip. Available in a wide variety of sizes. Useful for detail, wash, fills, and thin to thick lines.

Household brushes are handy for covering large areas quickly and good for laying colored grounds (see pages 40–41).

Pointed round Narrower than a standard round. Used for fine detailing, fine lines, spotting, and retouching.
Square wash The square wash can produce varying shapes and widths and often has a short, "flat-footed" handle for scraping, burnishing, and separating watercolor paper from blocks.

PALETTE KNIVES

For mixing and cleaning paint, the palette knife is a vital and necessary part of any paintbox, and you can also paint with it. For those who find brushes awkward or difficult to manage, the palette knife will provide the answer. Clean, well-mixed paint can be applied to the support with broad, vigorous strokes. For finer work, specially fashioned knives (known as painting knives) make a variety of delicate marks that are very effective. Of course, for more intricate painting and finish, brushes are the superior tools, but for certain kinds of effects, the painting knife can be extremely successful.

Knives, whether for palette or for painting, consist of a wooden handle,

and a metal (or plastic) blade. They may be straight or angular. The straight are continuous, from the wooden handle to the blade, which must be of either stainless steel or plastic. The angular have a bend that enables them to be manipulated more easily for both mixing, painting, and cleaning.

Broad-faced knives, like putty knives and printers' mixing knives, tend to be too large and clumsy for acrylic mixing and painting. The most suitable is an angular knife that is not too small or too flexible, that will clean, mix, and apply paint equally well. The aim should be to use both palette knife and brush, switching from one to the other as the situation demands.

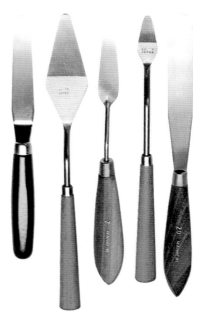

Palettes

Plastic palette

You can use any surface as a palette, providing it is nonabsorbent. The wooden palettes used by oil painters are not suitable, as you will be unable to remove the paint once it dries. There are two special types of palette sold for acrylic work: one is white plastic, which can be easily cleaned, and the other is the "Staywet" palette shown on the right. This is especially good for outdoor work, where fast-drying paint can be a problem. The paint remains damp and malleable while you are working and if you put on the plastic lid after a working session you will find the colors still usable a week or two later.

Staywet palette

Staywet palettes don't give much room for mixing, however, and many artists prefer improvised palettes, such as a sheet of glass or formica, where there is no restriction on size. If you work on a small scale, or use acrylic mainly in the watercolor mode, you could use plastic or china watercolor palettes, or even old china or tin plates.

Plate glass, edges bound with tape for safety

Whatever type of palette you decide on, try to arrange the colors in some sort of order, or you may make mistakes when mixing. The darker colors in particular are hard to tell apart in concentrated form, and you could find yourself picking up black when you wanted blue. It doesn't matter which order you choose as long as it has a logic and you can remember it

Supports

PAPER AND CARDBOARD

You can apply acrylic to virtually any paper or cardboard provided it is not greasy; any oil content will repel the water-based color. This means that you cannot use a surface that has been prepared for oil painting, such as oil sketching paper. Watercolor paper is the most popular choice. Three different types are available: rough (not pressed), medium rough (cold pressed), and smooth (hot pressed). Rough is not easy to work on because you need a lot of paint to cover the pronounced texture. Cold pressed, which has enough texture, or tooth, to hold the paint in place, is a good choice, but hot-pressed paper or smooth matte board can also produce interesting effects. The paint slides around more on a smooth surface, so that you can exploit the effect of brush marks.

You can also use pastel papers, made in two textures and a wide variety of colors. These will need to be stretched to prevent them from buckling, as will lightweight watercolor papers.

Good-quality watercolor and pastel paper are acid-free, which prevents the fragile watercolor and pastel pigment from possible spotting or discoloration over time. But the tough skin formed by acrylic paint seals and protects the paper, so your work will not be harmed by a slight acid content. This means you can use less expensive surfaces.

BOARDS

There are a number of different painting boards on the market. The most expensive boards—still a more cost-effective choice than ready-made canvases—are surfaced with fabric, while the others have a simulated canvas grain. Both types are primed during production, usually with acrylic so that they are suitable for both oil and acrylic painting. If you are not sure how the surface was primed, ask the supplier; remember, you cannot use acrylic on oil-primed board.

Another board often used for acrylic work is masonite, available from building supply centers. This has

CANVAS BOARD

DALER BOARD

PRIMED PAPER

two major advantages—it is inexpensive and you can cut it to whatever size or shape you like, whereas painting boards are made in standard formats. Masonite has a shiny surface, but you can counteract this by sanding it lightly before priming with acrylic gesso.

MAKE YOUR OWN CANVAS BOARD

Stretched canvas has a slight give that some painters dislike. If you prefer a firm surface, glue fabric onto masonite, using acrylic gloss medium. This is a good way to recycle old sheets rather than buying canvas by the yard, but avoid synthetics, such as nylon, which could be too slippery to hold the paint.

1 Cut a piece of masonite to the desired size, and spread it evenly with a layer of acrylic gloss medium.

2 Cut the fabric with enough surplus to take around onto the back of the board. Place it on the glued surface and smooth it with your hand.

3 Turn the board over and raise it off the table so that it does not adhere. Glue around the edges and stick the fabric down, folding it in at the corners.

BOARD (SMOOTH SIDE)

HARDBOARD (REVERSE SIDE)

PLYWOOD

STRETCHING YOUR OWN CANVAS

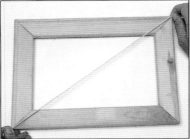

1 Assemble the stretchers. Check whether the corners are true 90° angles by stretching a piece of string across diagonally. Adjust if necessary.

2 Place the stretcher on the canvas and cut the canvas to size, allowing sufficient fabric around the edges to fold over onto the back of the stretchers.

3 Staple or tack one long side of the canvas to the edge of the stretcher. Then turn it over, pull the canvas with your fingers, and staple the other side. Repeat for the short sides.

4 Staple or tack the canvas onto the back of the stretchers, leaving at least 2 in. (5 cm) free at the corners. Miter the corners in two stages. First turn down the point of canvas so that it forms a pleat on either side.

5 Fold down the pleats and staple or tack through all the thicknesses. If you are using a staple gun, place the staple diagonally, with one end in each stretcher. If tacking, use two tacks.

6 Prime the canvas with acrylic gesso, using a household brush. If you prefer to keep the natural color of the canvas, prime it with acrylic matte or gloss medium (see page 19) instead.

Easels

Unless you are using thin washes of acrylic, any one of the available easels could suit your purpose. The final choice will depend on what size you normally work on, the type of support you paint on, whether you prefer sitting or standing, and whether or not you need an easel that is portable.

If you use a lot of water with the paint and apply it in washes of thin, runny color, then an upright easel is not for you. An adjustable drawing board that tilts to any convenient angle could be the answer. Or, if you prefer something that can be folded up and carried around, an easel that adjusts to a horizontal position to prevent the paint from running off would be more suitable.

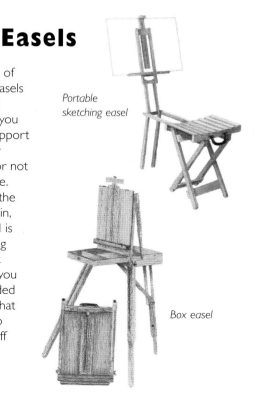

Portable sketching easel

Box easel

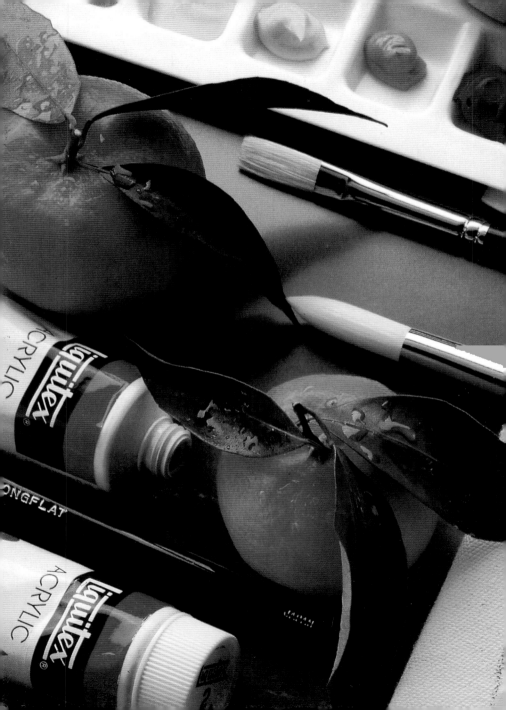

Techniques

Because acrylic is both a new medium and a highly versatile one, there is no time-hallowed body of techniques as there is for oils and watercolors. This is in a way an advantage, as you don't have to start with a list of "do's and don'ts," but it does make it hard to know how you should proceed. The aim of this section of the book is to provide some advice on how you can use the paints to their best advantage. Some of the techniques listed are traditional ones, borrowed from oil or watercolor painting, while others are peculiar to acrylics. You will find practical hints on such basics as choosing the most suitable painting surface, and you will also discover how to make collages, how to create stunning textural effects, and how to mix acrylics with other media, such as ink and pastel. Start by looking through all the techniques to gain some idea of the many exciting possibilities.

Getting to Know the Paints

If you are new to acrylics, it is a good idea to become familiar with them by experimenting on some inexpensive watercolor paper before you embark on a painting. Start by exploring the different consistencies of paint. Dilute it with water so that it resembles watercolor, and then progress to thicker applications as shown on these two pages. This will help you to discover the qualities of the paint and begin to find out how you might prefer to work.

By starting with water-thinned paint and no additional white, you will learn a lot about the colors themselves and how they differ. Set out all the starter palette colors, mixing each one with water in roughly half-and-half proportions. You will see that some colors are naturally much darker than others, and some have a slightly chalky consistency.

Next, explore ways of applying the paint. Make a flat wash by taking color over the paper with a broad brush. Then grade the wash from dark to light by adding more water for each stroke. Try the effect of sweeping diagonal strokes, and of dabbing color onto the paper with the tip of a round brush. Lay one color over another to create mixtures, or dampen the paper so that the colors mingle.

A flat wash made by taking a broad brush from one side to the other, then recharging it for each subsequent stroke.

A wash graded from dark to light by adding more water for each stroke.

Sweeping strokes, with each brush stroke pulled out toward the end.

MEDIUM-THICK PAINT

The tube consistency of acrylic paint is similar to that of toothpaste, so it can be used without the addition of water. However, a little water is helpful when mixing colors, because it encourages them to blend together, and it also makes the paint easier to spread when you are covering large areas. For this exercise, use a minimum amount of water, dipping the tip of your brush into your water jar and then into the paint. To achieve a more opaque finish, try the colors straight from the tube and then mixed with varying amounts of white.

Used straight from the tube, the paint remains transparent.

It becomes opaque when white is added.

THICK PAINT

By now you will have discovered how rapidly acrylic paint dries. Even at medium consistency it will harden within about 15 minutes, and less if you are working on an absorbent surface, such as watercolor paper. Really thick paints take much longer to dry. This allows you to blend and mix colors on the surface by laying them next to, or over, one another while still wet. You can also build up rich impastos, exploit brushwork to the fullest, and apply paint with a painting knife. These techniques are described later in this section. For these experiments it is best to use a primed canvas board, which is nonabsorbent and keeps the paint wet longer. You can create unusual effects by laying this thick but transparent paint over other colors.

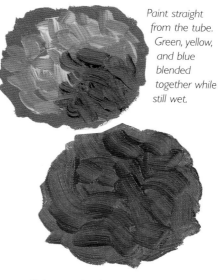

Paint straight from the tube. Green, yellow, and blue blended together while still wet.

Paint mixed with impasto medium becomes thicker but retains its transparency.

Blending

Blending means merging one color or tone into another so that there are no perceptible boundaries between them. Because acrylic dries fast and thus can only be manipulated on the painting surface for a short time, it lends itself less readily to blending techniques than other paints. However, blending can be done.

The method depends on the kind of painting you are planning. If you are using very thin acrylic and aiming at a watercolor effect, you can blend colors by dampening the paper and painting wet-into-wet (see pages 46–47), which will spread and diffuse the colors so that they run together.

This method is excellent for vague, atmospheric effects, but less suitable for modeling form, when you need more precision. If you want to merge two colors in one area of a picture— perhaps a vase in a still-life painting— lay down the first color and brush over the edge lightly with clean water so that it is still damp when you put down the next color.

The thicker you use the paint, the longer it will stay wet, making blending easier, but you can prolong the drying time even further by adding retarding medium to the colors as you mix them. This will allow you to "push" one color into another.

Blending can also be done with a dry brush method (see pages 56-57), laying down an area of flat color and then working over it lightly with a small amount of paint on a bristle brush.

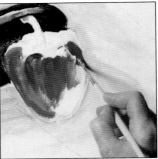

2 Painting the darkest and lightest areas of the eggplant first helped the artist to judge the strength of color needed for the pepper, which is initially blocked in with brush strokes following the forms.

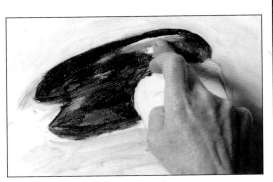

1 The paint has been mixed with retarding medium, and remains wet for long enough to blend one color into another with a finger. The working surface is canvas board.

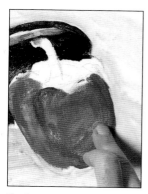 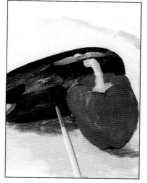 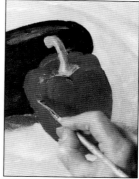

3 Again a finger is used to blend one color into another. The gradations of tone on the pepper are quite subtle.

4 Further dark colors are applied to the eggplant. A nylon brush is used throughout, as this is softer than a bristle brush and does not leave pronounced brush marks.

5 Yellow has been added to the basic red mixture to produce a brilliant orange-red, which is now stroked gently onto the side of the vegetable. The retarding medium makes the paint more transparent so that new applications do not completely cover the underlying colors.

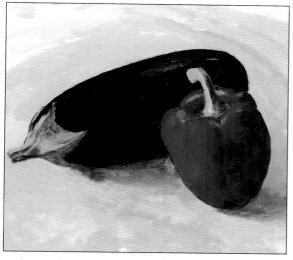

6 The brush marks are barely visible, and there is no obvious boundary between each color and tone. Although retarding medium is helpful, it needs to be used with caution. On a nonabsorbent surface such as primed canvas board, the paint remains tacky for some time, and there is a danger of accidentally lifting off small areas of color.

Broken Color

The term "broken color," which refers to any area of color that is not completely flat, covers a wide range of painting techniques. Dry brush and scumbling, for example, both produce broken-color effects, as does dragging a thin wash of color over a rough watercolor paper. In the latter case the paint will adhere only to the raised grain of the paper, producing a slight speckling.

However, broken-color effects are most often seen in opaque techniques. If you look at landscape painting in thick acrylics or oils, you will probably see that any large area of sky, sea, or grass consists of many different but related colors. Examine close up a sky that simply looks blue from a distance, and you may be able to identify a wide range of blues, and possibly some mauves, greens, and touches of brown as well. These colors all mix in the eye to read as blue.

Broken color effects are often created by working on a colored ground that is only partially covered by the paint, or by laying down a layer of flat color and working over it with other colors. Acrylic is particularly well suited to the latter method, as the first layer of paint will dry quickly.

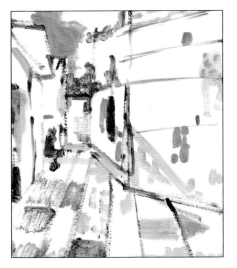

1 The composition is roughly mapped out with a few linear brush strokes before the artist begins to apply small, separate areas of color. She is working on heavy, moderately textured watercolor paper.

2 For the sun-struck white areas of the building, thick paint is used over the earlier thin washes.

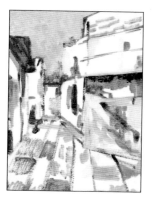

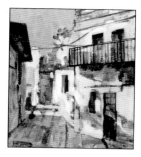

3 Although she is building up the painting with a patchwork of colors, the artist takes care to establish color relationships, repeating the blues and yellows from one part of the picture to another.

4 In an architectural subject it is important to maintain correct perspective and straight verticals. A piece of spare board is used as a ruler, with the brush drawn lightly along the edge.

5 Notice how the paint surface varies. On the buildings particularly, transparent washes in the shadow areas contrast with thicker paint, where the grain of the paper has broken up the brush strokes to give a textural effect.

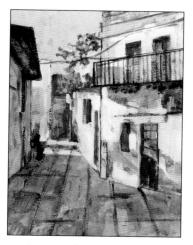

6 The painting is nearly complete, but the foreground is not yet sufficiently strong. A large soft brush is used to lay washes, or glazes, of thinned paint, which create pools of deeper color.

7 In each area of the picture, both the colors and the brushwork are nicely varied, and the contrast between thick and thin paint adds to the lively, sparkling effect.

Building Up

The way you proceed with a painting in acrylics depends to a large extent on your individual working method and on how you are using the paint—thick, thin or medium.

If you are exploiting transparent techniques on paper, you will want to begin with light washes of color, building from light to dark in the traditional watercolor manner.

Acrylic is probably used most frequently at its tube consistency, perhaps thinned with a little water, but basically as an opaque paint. In this case, it doesn't matter very much where you begin or which colors you put down first, because you can overpaint as much as you like without harming the colors beneath.

However, a good general rule for all painting is to block in the most important areas of tone and color first and then work all over the picture at the same time, always bearing in mind the relationship of the various shapes, tones, and colors. It is seldom wise to take one part of a picture to a high stage of finish before tackling another, as this can create a disjointed composition.

If you plan to contrast areas of thick and thin paint, perhaps using impasto for highlights or foreground objects, start thin and build up gradually. Although you can change and correct colors by over-painting, you won't be able to turn a heavily painted area with obvious brush or knife marks into a thin, flat one.

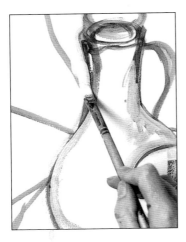

THE OPAQUE TECHNIQUE ON PAPER

1 Working on watercolor paper with a medium-textured surface, the artist first made an outline brush drawing to establish the placing and shapes of the objects. She now adjusts and clarifies the drawing by painting out incorrect lines with white paint.

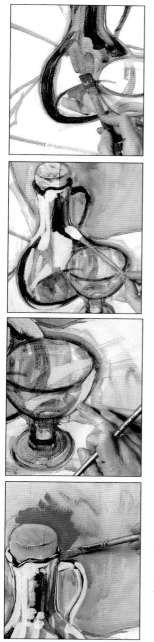

2 With the drawing established, she lays in color, using water-thinned paint for the carafe to simulate the transparency of the glass. Although the glass has a greenish tinge, it reflects the color of the background, so a warm brown is chosen.

3 The subtle colors of the glass have been built up with a series of transparent washes, with thicker paint applied with a bristle brush for the highlights on the carafe. The same paint is used to work into the dark area on the right.

4 Thick paint is again used for the highlight on the side of the glass. Because it threatened to overlap the edge, the artist pushes it into place with her finger.

5 The background is strengthened with a thicker application of paint. Using a nylon brush, which is better for precise definition than a bristle one, the artist takes the color carefully around the edges of the cork and the handle of the carafe.

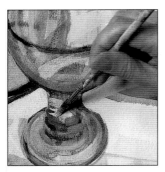

THE OPAQUE TECHNIQUE CONT.

6 The colors of the wine glass are finely nuanced yet quite strong, requiring careful color mixing. These patches of deep turquoise, like the curve at the bottom of the glass, must also be placed accurately, as they describe the forms. A nylon brush is again used.

7 In order to achieve the elusive quality of the glass carafe, which is somewhere between green and brown, a glaze of transparent greenish yellow is laid over the original browns and whites (see Glazing, pages 48–49). The glaze is applied with a large soft brush, and the paint is thinned with water alone. A glazing medium can be used, but water is often preferable for large areas.

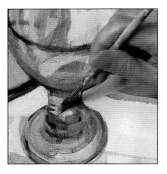

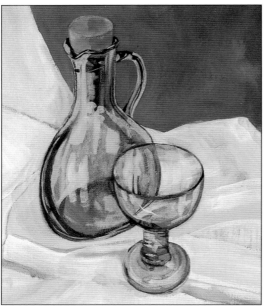

8 The finished painting shows how the consistency of the paint can be varied to suit the subject. On both of the glass objects, opaque highlights overlay transparent washes, while relatively thick paint has been used for the drapery.

OPAQUE TECHNIQUE WITH GOUACHE

1 After the outline has been completed in pencil, an opaque wash is applied. Try to work quickly so that the wash is worked with when very wet. It will then dry to an even surface.

2 Once the opaque wash has dried, the thinner translucent washes can be applied on top. The paint is mixed until it is quite runny—this mixing can be done on the illustration. Work quickly so as not to disturb the opaque wash beneath. Some mixing is desirable.

3 Fine detail can be added after the washes with a fine felt-tip pen. Do not use a dip pen and ink, as the ink will bleed into the paint.

4 When all the washes are dry, other details can be added with thick gouache, as can be seen in the stars in this illustration. Modeling and shadows are rendered in thin washes, such as the creamy shadow on the cow.

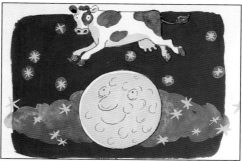

Colored Grounds

Canvases and boards sold for acrylic painting are usually white, but you may find it helpful to lay on a tint before starting to paint. Some artists like a white surface, particularly if they intend to paint thinly, because light reflected back through the paint gives the work a luminous quality. Others find a white surface disturbing, as it makes it difficult to judge the relative lightness or darkness of the previous colors.

There are no true whites in nature, so the canvas or board is providing an artificial standard. Virtually any color you put on will look dark in contrast, and you may find you are working in too light a "key." If you tint the board with a mid-tone, you can work up to the lightest tones and down to the darks.

Coloring the ground is easily done—brush some thinned acrylic all over the surface and it will be dry in minutes. Usually a neutral color is chosen, such as gray, gray-blue, or an ochre-brown. Some artists always use the same color; others choose a different one for each painting.

The color can contrast with the overall color key of the painting; for example, a warm brown or yellow for a snow-scene with a predominance of cool blues and grays. Alternatively, you can use a ground color that tones in with the applied colors.

Artists who work on colored grounds often deliberately leave small patches of the ground uncovered, whether it is in a toning or a contrasting color. This helps to give the picture unity, as repeating colors from one area to another ties the separate elements together.

LAYING THE GROUND

Laying a ground color is simplicity itself, all you do is paint a color over the entire surface using a broad brush. If you prefer to use the paint in a series of thin layers, either on paper or canvas, a transparent color might be best, using well-diluted paint. You can also use thick paint, vigorously working it into the surface so that it provides a slightly rough texture.

A rag spreads the paint thinly so that a strong color, such as the red used here, becomes paler.

A broad brush, used with medium-consistency paint, makes a series of striated marks that provide added interest to the painting.

An uneven watercolor-type wash also makes a good ground for many different painting techniques.

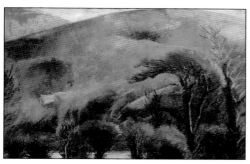

Whatever your subject, you can use a colored ground as a starting point. First decide what the overall color scheme is to be, because the ground will influence the applied colors.

A medium-blue ground, on watercolor paper, was used for a landscape using harmonies of blue and yellow.

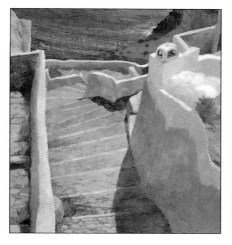

LEFT: A traditional ochre ground helps to warm up the whites, and contrasts well with the blue of the sea. BELOW: A cadmium red ground was used for this painting of trees.

Impasto Technique

Another technique borrowed from oil painting is the use of thick paint that stands out from the picture surface. Impasto can be applied throughout a picture or in a single area. Thick paint, with highly visible brush marks, has a stronger presence than thin paint and will always draw the eye, so artists often restrict impasto to areas they want to emphasize. You see this effect in many oil portraits by Rembrandt (1606–1669), where thickly painted highlights on skin, clothes, and jewelry stand out strongly against the thin paint used for backgrounds and dark areas. Adapt this idea to a landscape or still life, painting the background objects to create the illusion of space.

IMPASTO MEDIUM

Most acrylic paints are runnier than oils, so if you want to use heavy impastos for an entire painting you may need to thicken the paint with acrylic gel medium (see page 19). This is also an economy measure, because without it you might need a whole tube of paint for one area. If you are using white, or a color with a high proportion of white, you are unlikely to need the medium. White is the thickest and most opaque of all the colors.

USING THICK PAINT

1 You may find yourself in trouble if you use thick paint from the start, because the colors will mix together. Block in the colors first with thinned paint, using a scrubbing motion to push them well into the surface.

2 Now begin to build up the sky with a thick, juicy mixture of white and phthalo blue. Try mixing the color only partially on the palette, so that each brush stroke consists of streaks of two or more colors of paint.

3 Introduce some yellow into the sky and foreground to contrast with the blues. Do not worry if the color looks too bright. Simply paint over it with another color while it is still wet, and the two will mix.

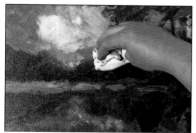

4 The thicker the paint, the longer it takes to dry. If the build-up of paint becomes too heavy for you to add colors without creating muddy mixtures, wipe some of the paint off with a rag before continuing.

IMPASTO TECHNIQUE USING GOUACHE

The impasto technique is probably more effective if you are working with acrylic paint, but using gouache can also be successful. The paint is used as it comes out the tube. Do not add extra water, as the consistency will be lighter, which will detract from the impasto effect.

In this example, the background area has been applied first in flat gouache to enhance the impasto effect. The orange paint is then applied as thickly as possible. Try to create as much surface texture as you can with the brush.

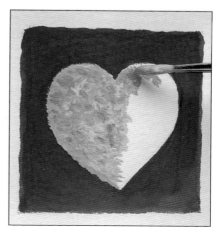

Line and Wash

Because acrylic can imitate both oil paint and watercolor, many of the old techniques can be adapted to the new medium. Line and wash, a traditional watercolor technique, is one example. It dates from the 17th century, before watercolor had really come into its own as a painting medium, and was used mainly to lay flat washes of color over pen drawings.

Since that time, however, artists have used line and wash in more inventive and expressive ways. The problem with the traditional method of making the drawing first and adding the color is that the two mediums can fail to gel, and it is difficult to avoid the effect of a colored-in drawing. It is usually better to develop the line and color simultaneously, so that you are constantly aware of the relationship you are creating between the two.

The kind of pen you choose will depend on the effect you want. Some line and wash drawings are fragile (the technique is much used for flower studies) and others are bold. Experiment with different pens, from fine nibs to fiber- and felt-tip pens or even ballpoints—an underrated drawing implement. You might also try using water-soluble ink, which will spread when wet color is laid on top, creating soft, diffused effects.

The paint for the washes should be kept thin, or it may detract from the effect of the drawing, so it is best to choose transparent pigments. It can be thinned with water alone, or with a mixture of water and medium.

1 Using a fine-tipped drawing pen, and working on smooth drawing paper, the artist draws the shapes of the flowers, keeping the lines light.

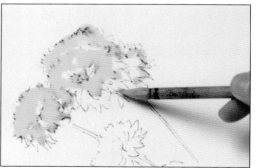

2 With the paint thinned to watercolor consistency, the artist touches in color with the tip of a Chinese brush. Because the ink is water-soluble, the wet paint spreads it slightly, giving a soft effect.

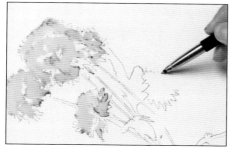

3 Further details are added with the pen, again using a light touch to avoid the effect of a filled-in drawing.

4 Green washes mix with the blue ink to create an impression of delicate shading on the leaves.

5 The pen is now used in a more positive way to draw into the leaves with diagonal strokes of hatching and cross-hatching.

6 A light wash is laid over the background and taken carefully around the edges of the flowers.

7 To provide a context for the flowers as well as some color contrast, the background wash was extended, and the top of the vase sketched in lightly in pen.

ABOVE: *Two examples of waterproof ink and gouache.*

Wet-into-Wet

When a new color is applied before the first one has dried, the two will blend together without hard edges. This wet-into-wet technique is used in both oil and watercolor paint, and hence for both opaque and transparent techniques in acrylic.

In oil painting, the wet-into-wet technique was much used by the Impressionists, notably Claude Monet (1840–1926), who painted landscapes on the spot at great speed, often laying one color over another so that they mixed on the picture surface. Thick acrylics can also be used in this way, but unless you work very fast or use the paint very thick indeed, you will need to mix the colors with retarding medium.

Watercolor wet-into-wet effects can be achieved, as in watercolor itself, by working on dampened paper. As long as the paper stays damp, so will the paint, so if it begins to dry before you have completed an area, simply spray it over with a plant spray—these are useful in acrylic work because you can keep the paints wet on your palette by occasional spraying.

You may also find it helpful to use a water-tension breaker, which improves the flow of the paint. This can either be mixed into the water you use for thinning the paint or washed over the painting surface itself. Retarder is not used for water-thinned paint; it is made for opaque techniques only.

PLOWED FIELDS USING THE WET-INTO-WET TECHNIQUE

1 Using a diluted mixture of raw umber, burnt sienna and deep violet, the artist blocks in the plowed field in the foreground. Color is spread quickly to prevent tide marks and blotchiness as the paint dries.

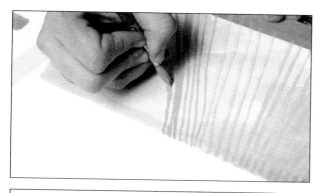

2 A darker tone of the wash color is used to paint the furrows. This is done before the wash is completely dry, allowing the new color to blend in slightly, thus preventing a hard, unnatural edge on the furrows.

3 The first row of trees is added in Hooker's green. This strong color ensures that they will stand out clearly from the distant trees on the horizon to be added later. The color is allowed to run slightly into the field color, thus preventing a harsh outline.

4 The far fields are painted in bright green and cadmium yellow, applied as flat shapes. No attempt is made to create distance by grading the color of the fields to indicate recession. Instead, the artist relies on the optical effect of the receding lines on the plowed fields to convey space and distance in the painting, even though the furrows converge only slightly.

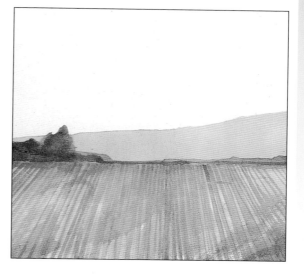

Glazing

A glaze is a transparent film of paint, usually applied over another color. It can change the underlying color without actually obliterating it, producing a subtle filmlike quality instead of a flat opaque finish. If the glaze is to show up clearly, the underlying color must be paler than the glaze itself. Occasionally a light colored glaze is used over a color that is the same tone, or perhaps even darker, but in this case the result is always subtle, adding a barely noticeable sheen to the glazed area rather than actually changing its color.

The strength of a glaze depends partly on the staining capacity of the particular pigment you are working with and partly on how much water or medium you use to dilute the color. Some pigments produce a stronger tint than others. For instance, phthalocyanine green makes a bright glaze that will tend to dominate the color underneath; a color with low tinting strength, such as raw umber, will tone down or modify the underpainting without

overpowering it.

If you use water by itself to dilute the color, the glaze dries to a dull, matte finish. When the paint is diluted with acrylic medium, it dries gloss or semigloss, depending on how absorbent the surface underneath is. A glaze mixed with medium is usually richer in color than one mixed with water, but the dullest of finishes can be enlivened and the color brought

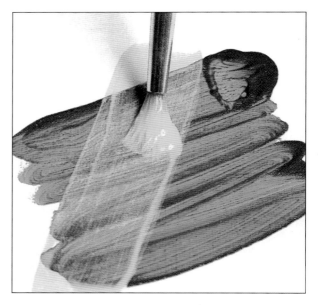

ABOVE: *You can dilute the glaze with water or acrylic medium—medium produces a richer, livelier color—and apply this over the underpainting. If a thicker glaze is desired, build up the color in several thin layers.*

up to its full potential by applying a coat of acrylic varnish, gloss medium, or acrylic fixative.

Multiple glazes can be super-imposed to create complex color variations. Always work from light to dark, gradually building up the tone and color until you arrive at the effect you want.

Glazes are often used over thickly impastoed paint and highly textured surfaces. The glazing gives a touch of delicate transparent color to an otherwise heavy finish. If the glaze is gently wiped with a tissue or rag while the paint is still wet, the darkest color will remain in the crevices, cracks, and indented marks. This produces an effectively varied surface which—if the glaze color is neutral and subdued enough—can often resemble that of an old oil painting or even a texture from nature. The bark of a tree or a mossy stone wall, for instance, could easily be depicted in this way.

Because acrylic colors retain a degree of transparency unless used very thickly, glazing, either selectively or over the whole picture surface, is a natural way of working. The method can be used for any subject but is especially effective for capturing the shimmer of water or the subtle colors of skin.

Glazing is also useful for toning down colors. When a picture is nearing completion, you may decide that one area is too bright. Rectify this by applying a gray or blue-gray glaze.

Successive layers of transparent paint were used for the face, with final touches of opaque pale pink laid over them on the nose, chin, and brow.

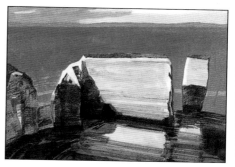

The dark tones and rich colors of the cliffs and the foreground water were built up gradually, with several layers of glazed color.

Transparent Techniques

As mentioned earlier, acrylic can be used like watercolor, with the picture built up from a series of thin washes of color. The advantage of acrylic over watercolor is that the former is non-soluble when dry, allowing you to superimpose any number of washes—watercolor remains water-soluble, so you can muddy the colors by applying too many layers.

For transparent techniques on paper, the best surface is watercolor paper, stretched if necessary. But these methods are not restricted to works on paper; lovely effects can also be achieved by using transparent overlays of color on canvas.

The American abstract painter Morris Louis (1912–1962), worked on raw (unprimed) canvas, using thin, transparent washes to build up over-lapping shapes in brilliant, translucent colors, and similar techniques can be used for representational work.

Louis and others among the group of artists who first adopted the new medium welcomed the fact that acrylic color could be laid directly on

unprimed canvas. The slight absorbency causes the paint to spread a little, creating soft edges and gently diffused colors that retain their brilliance. However, this is only one type of transparent technique on canvas; it can be equally effective on a white ground, with the colors applied in successive layers.

Thick, opaque paint always has the effect of advancing toward the front of the picture plane, while thin, transparent paint recedes. You can see this effect very clearly in this painting, where the rectangle of knife-applied paint seems almost to float above the thin colors.

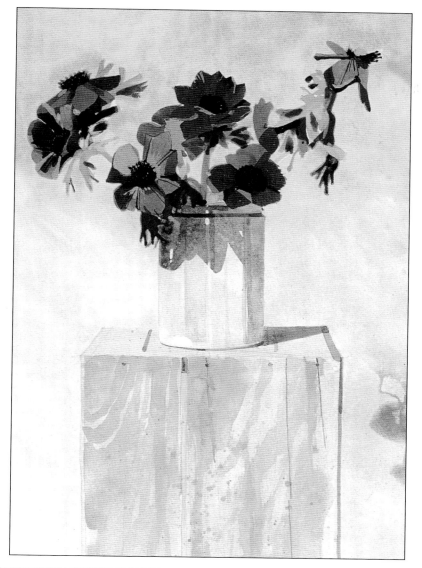

ANEMONES IN AN EARTHENWARE JAR by Ian Sidaway
Acrylic can be used in thin washes to produce an effect that is almost indistinguishable from watercolor. In the painting above, layers of transparent washes are applied to create the delicate shades of the flowers and background.

Brush Techniques

Some artists like to apply colors flatly or very smoothly, with no visible brush marks. But in most paintings, the marks of the brush and the way the paint is applied contribute as much as color and composition to the overall effect. Beginners often ignore this aspect of painting. Instead, their first concern is the accurate representation of the subject. But brushwork is very important, as a painting can be spoiled easily by sloppy brushwork.

Your brushes are your working tools, and the task of visual description becomes easier and more satisfying when you choose the right one for the job. Size is one consideration. There is also a variety of different shapes, and you need to become familiar with their possibilities.

Working on a smooth surface, such as acrylic sketching paper or primed board, try out all your brushes to see the kinds of marks they produce. Practice different ways of holding them, making sweeping strokes with the brush held near the end, and smaller, tighter ones holding it near the ferrule—this gives you maximum control, and is the grip to use for details, where accuracy is important. If you have both nylon and bristle brushes, you will find nylon best for laying flat color, while bristles give a more rugged texture.

▲ Large flat and medium flat brushes. These brushes make bricklike marks.

▶ A filbert brush produces a more rounded stroke, which can be graded to a point by reducing pressure at the end of the stroke. The brush can also be used on its side.

◀ A round-ended brush makes small dabs and dots, or lines that can be varied from thick to thin by increasing or decreasing the pressure.

▼ Sweeping strokes made with a bristle filbert brush held loosely near the end.

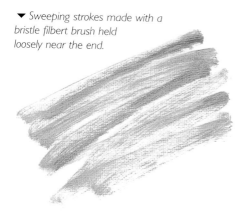

▲ The smallest pointed nylon brush held tightly at the ferrule.

▼ A small, pointed nylon brush held loosely in the middle.

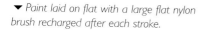

▲ A medium round brush held at the end vertically, with the surface horizontal.

▼ Paint laid on flat with a large flat nylon brush recharged after each stroke.

▶ Medium-size flat bristle brush used with dabbing motion and held near ferrule.

53

Brushwork

A good painting, whether a landscape, a still life, a flower painting or a portrait, relies for its success on several factors. One of these is the way the paint is put onto the painting surface.

Inexperienced artists often fail to give much thought to brushwork, which is hardly surprising since the problems of making a subject look convincing require quite enough effort. But it is important to remember that a picture is more than a representation of the world—it is an object in itself, with its own physical presence. Brushwork is not just the icing on the cake—it is an integral part of the image.

Apart from creating a lively and attractive picture surface, the way you use your brush can help you describe objects. If you are painting flowers in thick paint, for instance, you can often represent a leaf or petal with one deft flick of the brush. In a landscape you can let your brush follow the direction of a tree trunk or the furrows of a plowed field. This will also give your painting a sense of movement and dynamism.

Acrylic paints hold the marks of the brush very well, especially if you thicken them with a bulking medium, so it would be a pity to ignore this opportunity.

Brushwork can play a part in thin acrylic techniques, too. You might use long, linear strokes for hair in a portrait, calligraphic squiggles and broken lines for reflections in a watery landscape, and loose blobs for foliage. It is worth experimenting with a variety of brush shapes to find out what kinds of marks each one can make.

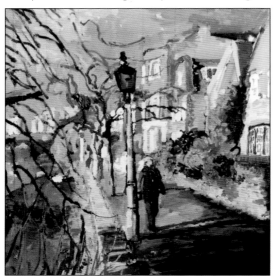

STRAND ON THE GREEN by Gary Jeffrey
Working on primed paper, the artist has used thick, juicy paint, and his energetic and positive brushwork gives a feeling of excitement and movement to the composition.

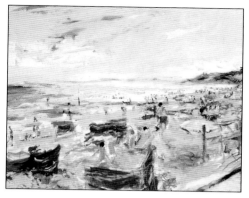

BOURNEMOUTH BEACH by Jacquie Turner

Equally lively and exciting brushwork is seen in this delightful painting done on smooth watercolor paper. Here there is a contrast between thick and thin paint, as well as between deft stabs and flicks of the brush and smudged paint—this artist uses her fingers as well as brushes.

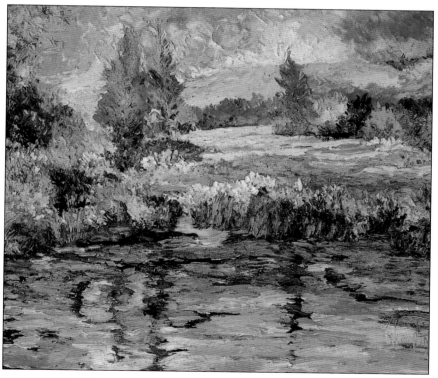

REFLECTIONS by Valentina Lamdin

No area of this painting, done on canvas, is flat—all the tones and colors have been built up with an intricate network of small brush strokes reminiscent of the Impressionist painters.

Dry Brush

Dry brush is a technique common to all the painting media, whether opaque or transparent. It simply means working with a minimum amount of paint on the brush so that the color below is only partially covered.

You can work dry brush straight onto an unpainted surface on paper or canvas, but it is usual to work it over a previously laid color, thus achieving a broken color effect (see pages 34–35). The method is much used in watercolor—and acrylic in the watercolor mode—for achieving textured effects, such as hair and fur or grass and foliage.

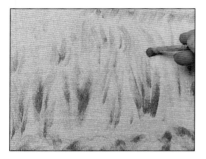

1 Work on a textured surface, such as canvas or canvas board. Make a thick mixture of paint, pick it up with the tip of the brush, and pull the paint lightly over the surface to suggest the upward growth of the grasses.

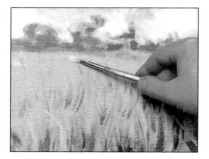

2 Build up the grasses with a variety of colors. Use horizontal strokes for the far end of the field. In the foreground you can see how the paint catches only on the raised grain of the surface.

For thin acrylic, you will need to use a soft brush, ideally a flat-ended one, with the hairs splayed out slightly. Experiment on a spare piece of paper beforehand; it is important to get exactly the right amount of paint on the brush or it will go on too heavily and spoil the effect.

If the painting is in thick or medium-thick acrylic it is probably best to use a bristle brush; the fan-shaped ones sold as blending brushes are useful. You can brush equally thick, fairly stiff paint over the underlayer, or use thin paint over thick, depending on the effect you want to achieve.

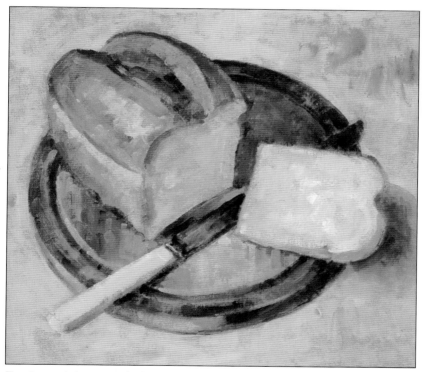

The above painting was worked on canvas and was given an overall tint. The texture of the crusty loaf is accurately represented by successive applications of dry brush. Because acrylic dries so fast, one layer of paint can be laid over another almost immediately. On the breadboard, considerable variations of color and tone have been achieved by laying one color over another. The dry brush method is now again used for the soft, broken line of shadow beneath the loaf. Dry brushing is an excellent method for suggesting texture; it has also allowed the artist to build up subtle but lively interactions of color.

Alternative Techniques

COLLAGE

The word collage comes from the French *coller*, to glue or paste, and it describes a picture made by gluing pieces of colored paper, fabric, photographs, newspaper cuttings—or anything you like—onto a working surface. These can be combined with paint, or the whole composition can consist of glued-on fragments.

Acrylic is the perfect medium for collage work. Both paints and mediums have powerful adhesive properties, and are capable of securing quite heavy objects to the picture surface. If you use texture paste (as in the picture below) and press objects into it—like shells, scraps of tree bark, grasses, or even keys, beads, or small piece of jewelry—you can create three-dimensional effects akin to relief sculpture. In such cases, a

VIEW OF MOUSEHOLE by Mike Bernard
Although this work on paper contains elements of collage, the artist prefers to describe it as a mixed-media painting, because he does not rely on collage alone to produce areas of texture. He has combined collage with pastel, paint, and colored inks, applied with a number of different tools, such as rollers, sponges, toothbrushes, pieces of cardboard, and palette knives.

final coat of colorless medium should be used to seal and protect the work.

Alternatively, you can use paint and paper alone, placing the emphasis on two-dimensional pattern and the juxtaposition of colors. Some artists employ a layering technique, gluing on fragments of colored paper with acrylic medium, covering these with paint and perhaps more medium, then more paper and paint. Others will begin a painting in the normal way and then collage certain areas.

A collage can be as simple or complex as you like; it can be abstract or semi-abstract, realistic or purely decorative. Collage is essentially an experimental technique, so there are no hard and fast rules. One word of warning, however. If you are trying the three-dimensional approach and using paint and medium thickly, work on a rigid support such as a plywood panel, as otherwise the paint may crack after drying.

WINTER LAKE by Jill Confavreux

This painting evolved as part of a series on the theme of frozen ground. The working surface was a medium watercolor paper, onto which the artist glued acid-free tissue paper with gloss medium. This texture formed the ground over which she painted and poured acrylic glazes, followed by a light scumble of gold and silver oil pastels. These acted as a resist for further applications of paint, creating some lovely effects.

This detail shows the variety of textural and color effects produced by this layering method. The final stage was to apply a glaze, cover the whole surface with plastic wrap, and peel it off when the glaze was dry.

EXTRUDED PAINT

The diverse nature of acrylics, together with the large number of specialized mediums you can use to alter the character and handling properties of the colors, encourages an experimental approach. You need not restrict yourself to conventional brush painting—you can build up layers of solid paint with a knife (see Knife Painting, pages 62–63) and you can squeeze, or extrude, the paint onto the working surface from a nozzle.

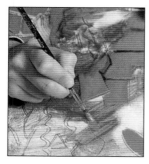
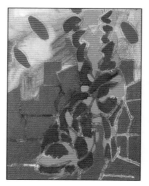
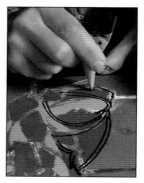

1 A design—based on a high-heeled boot—was worked out in a sketchbook, and guidelines were penciled on the working surface, in this case a canvas board. The artist now begins to build up the picture with varying consistencies of paint.

2 By carrying out several stages of painting, the artist has given himself a foundation on which to begin the extruding. This method needs a decisive approach, since mistakes cannot be easily corrected.

3 Using a pastry bag improvised from tracing paper, the artist begins to outline the toe of the boot with black. He has bulked out the paint by mixing it with impasto medium.

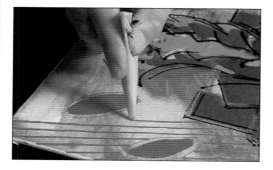

4 Several pastry bags are needed to cater to different colors. A new one is now used to draw rows of carefully spaced diagonal lines, leaving the painted ovals uncovered.

5 The surface is then covered with a network of lines, circles, and small dots. Care must be taken not to rest the hand on completed parts of the work, so the board is turned around from time to time.

6 At this stage, the picture is propped up at a distance to assess how much more work needs to be done. The boot clearly requires further attention, as it is less heavily textured than the background.

7 Using the pastry bag again, solid orange lines are made inside the earlier red ones. The same orange was used first to outline the boot and then to strengthen the oval shapes in the background. The rest of the boot was built up with a finer network of lines overlaying the original flatly painted colors.

PALETTE-KNIFE PAINTING

If you enjoy applying paint thickly, try using a painting knife (a selection of these is shown on page 22). Knife painting is another form of impasto, but the effect is entirely different from that of brush impasto. The flat blade of the painting knife spreads out and squeezes the paint to produce a flat plane with a ridge where each stroke ends.

The ridges catch the light and cast tiny lines of shadow that you can use to define the edges and shapes in your subject. In a flower painting, for example, make separate, differently shaped knife marks for each petal or leaf and use the side or point of the knife for fine lines such as stalks.

Painting knives are also good for imitating textures. A rough stone wall, for example, could be rendered with a variety of knife strokes, and later glazed over with other colors. Impasto methods are often combined with glazing techniques.

A painting done entirely with painting knives has a lively surface effect and can enhance the drama of the subject; this could be the perfect technique for a rocky landscape. But as with brush impasto, knife painting can be confined to selected areas, adding emphasis to foreground grasses or tree trunks, for example.

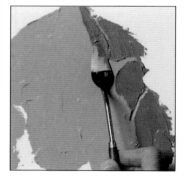

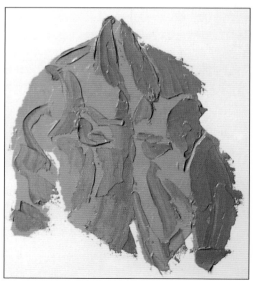

1,2 The first layer of paint is allowed to become touch dry before a second color is laid on—a hairdryer is helpful here. Using a pointed knife, with the paint at tube consistency, the artist strokes the color onto the surface. The first application of paint was pushed onto the surface, so it is relatively flat. The brown has been applied more lightly, creating thick ridges with distinct edges.

3 By twisting the knife slightly as he works, the artist allows the point to scratch into the paint, thus combining knife painting with a version of the sgraffito technique. This outline, as seen in the white highlights, enhances the overall edginess of the image.

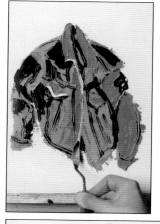

4 White paint is now applied with the point of the knife to reinforce the linear element. These triangular knives are capable of surprisingly precise effects.

5 An ordinary straight-bladed palette knife is now used to remove small areas of the still-wet brown paint, suggesting the buttons on the jacket. Thickly applied paint dries slowly and can be manipulated on the surface for a considerable time.

6 Further knife strokes of both black and white paint were added in the final stages to complete the definition of the jacket.

MASKING

It is extremely difficult to paint a completely clean edge or a perfectly straight line—the brush almost always wobbles or the line meanders askew. It can help to hold your brush against a ruler, but even then the paint tends to slip underneath. So it is better to use masking tape.

Masking techniques are often used by abstract painters who want crisp, hard-edged divisions between shapes, but they also have their uses in representational painting. Suppose you are painting a white building using transparent techniques and want to keep the paper clean for the white areas. To avoid any slippage over the edges, all you need to do is stick on some masking tape and remove it when you have painted the background.

Or you might be using opaque techniques to paint an interior with a window frame, and you could use masking tape to create a sharp division between this and the view outside. In a combination of thick and thin paint, you may want some areas of textured impasto with distinct edges—perhaps for a patterned fabric. Masking tape can be stuck down over thinly applied paint, so you could lay on the thin color first and then cut pieces of masking tape to fit around each shape, thus allowing you to work freely without losing the clarity of the edges.

Masking tape can be used on paper or canvas, providing it is not too heavily textured, in which case the tape will only adhere to the raised grain, allowing paint to slip beneath.

1 Thin red and yellow paint is streaked onto canvas board and allowed to dry before masking tape is applied.

2 The contrast between opaque, flatly applied paint and thinner, rougher applications is to be one of the features of the painting. The brilliant red is applied with a soft brush, which evens out the brush strokes.

3 Finally, the tape is peeled off carefully, leaving a crisp edge. It must be removed before the paint is dry, because dried acrylic forms a plastic skin, which will come away with the tape.

CREATING ABSTRACT SHAPES

In the painting below, the artist has used many basic techniques to achieve these abstract effects. Masking tape was applied in order to obtain a definite edge on the ellipses. Texture paste, mixed with paint, then scraped with a plastic comb to produce a broken surface, helped to throw the ellipses forward into the picture plane.

Masking tape was used to delineate and protect the three main shapes before the background wash was applied. The tape had to be pressed firmly to prevent the paint from seeping underneath.

SCRAPING

Although a brush is the most natural implement for applying paint to the picture surface, it is by no means the only one. Paint can be squeezed on (see Extruded Paint, pages 60–61) and it can also be scraped onto the surface.

This method—which can be carried out with an improvised scraper such as a plastic ruler or half an old credit card, or with one of the metal-bladed tools sold for removing wallpaper—is allied to knife painting, but produces flatter layers of paint that cover the surface more thinly. It is thus ideal for layering techniques in which transparent paint is scraped over opaque or vice versa. You can also scrape lightly tinted acrylic medium over existing color, producing a glazing effect that enriches the color and gives it depth.

You can introduce variety by contrasting thinly scraped areas of paint with textured ones. Ridged patterns can be created with a notched plaster scraper. Or you could devise your own scraper by cutting notches in a piece of stiff board or plastic. The same method can be used for laying an under-texture modeling paste (see Texturing, pages 74–75).

1 A plastic card is used to drag paint thinly across the surface. A metal paint scraper can also be used, but the flexibility of plastic makes it more sensitive. The working surface is a canvas board laid flat on a table and secured with tape.

2 A darker color is laid over the blue. Although the paint is at tube consistency, coverage is thin enough to reveal the color beneath, giving an effect almost like that of glazing.

3 The greater rigidity of a paint scraper produces thicker, more irregular coverage, an effect that is now used to build up surface texture in places.

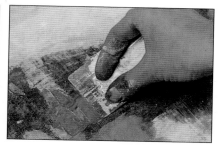

4 The card is pulled downward to create a veil of color that accurately suggests the reflections. The pigment used in this case is relatively transparent.

5 The foliage on the far bank of the lake is built up more thickly. The paint is the same consistency as before, but instead of being dragged across the surface it is applied in a series of short, interrupted strokes.

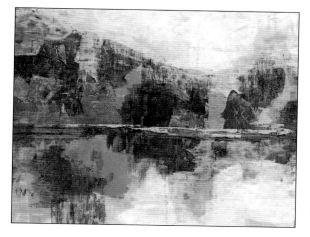

6 The finished painting shows a variety of effects that would be impossible to achieve with any conventional painting tool. Thin veils of color contrast with discreet semi-impastos and lively edge qualities.

SCUMBLING

One of the many methods of achieving broken color effects, scumbling involves scrubbing an uneven layer of paint over an existing color. Scumbling is much used by oil painters, but since the underlying layer must be completely dry before the scumbled paint is applied, the method is even better suited to fast-drying acrylic. Indeed, it is such a natural way of working in acrylic that artists will sometimes be unaware that what they are doing constitutes a technique.

Whether you choose to scumble a contrasting color or a similar one

A SCUMBLED SKY

1 Lay flat base color and allow it to dry. Using unthinned paint and a bristle or synthetic brush, apply a paler mauve-blue lightly over it. Vary the direction of the brush strokes and leave patches of the first color visible between them.

2 When the first scumbled layer is dry, introduce a third color, such as cerulean blue. Take care not to cover the first colors completely; the effect comes from the way one color shows through another color.

depends on the effect you are seeking. You might, for example, scumble several subtle colors over a base coat of mid-gray to suggest the texture of a stone wall, or you might enrich a vivid color, such as a deep, bright blue, by scumbling over it with shades of violet or lighter blue.

The most important thing to remember is that you should not cover the color beneath completely, so the paint is usually applied with a light scrubbing action—using a stiff brush, a rag, or even your fingers. If you are working on canvas or canvas board, the grain will help you, because the paint will be deposited only on top of the weave, but scumbling can also be done quite effectively on a smooth surface such as primed hardboard.

Generally the paint is used fairly thick, but you can scumble with water-thinned paint provided you follow the dry brush procedure and squeeze most of the paint out of the brush. You can also make semitransparent scumbles by mixing the paint with gloss or matte medium.

Scumbling is an imprecise method, impossible to restrict to a small area, so before turning her attention to the sky, the artist has protected the area by covering it with tape. When the tape was removed it left a crisp edge. Masking tape was also used to protect the margins of the paper, which resulted in a perfectly defined straight edge that complements the edge qualities in the painting and contrasts with the soft, broken-color effects of the scumbling method.

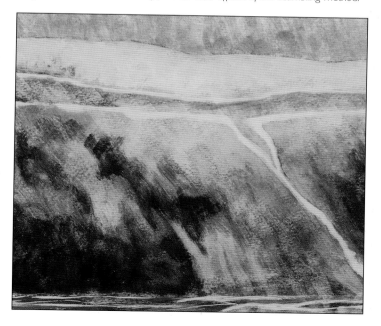

SGRAFFITO

Sgraffito (from the Italian *graffiare*, to scratch) means scoring into the paint to reveal either the white of the canvas or board, or another color below. Sgraffito is another technique that has been borrowed from oil painting.

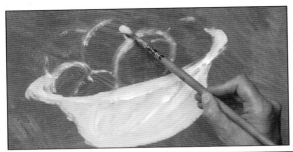

1 Paint can be scratched to reveal the white surface below, but in this case the artist intends to scratch back to another color. She therefore lays a red ground all over the canvas board before painting the fruit and basket.

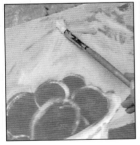

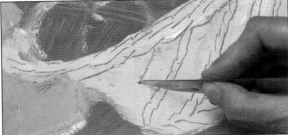

2 When painting the blue background, she deliberately leaves a little of the red showing between the brush strokes. She will reinforce the color contrast by scratching into the blue later.

3 She has used retarding medium, so the paint is still sufficiently wet to be removed with the point of a knife. If it becomes too dry, harder pressure has to be applied, and this can remove the first layer of paint as well as the second.

4 Both the point and the serrated edge of the knife are used to create a variety of lines in the blue background.

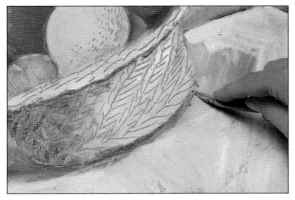

5 With the fruit now painted, the point of the knife was used to pick out dots of red on the lemon. A light glaze was laid to create the shadow on the left side of the basket, and now the pattern is built up with further knife scratching.

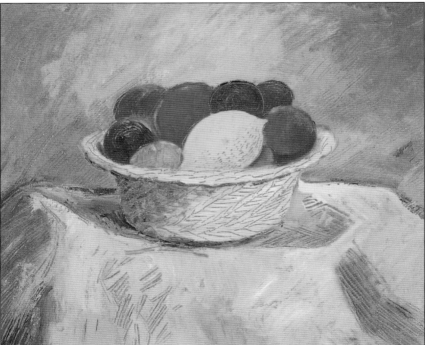

6 The effect of the painting relies partly on the color scheme, which has been well chosen to provide blue/red contrasts in each area. The red sgraffito into blue balances the bright colors of the fruit and gives extra impact to the scratched lines.

71

SPATTERING

Spraying or flicking paint onto the picture surface is an excellent way of suggesting certain textures, and may also be used to enliven an area of flat color—perhaps in the background of a still life.

Watercolor landscape painters sometimes use spattered paint to convey the crumbly appearance of cliffs and sandy beaches, or spatter opaque white paint to describe the fine spray of a breaking wave. Spattering has obvious applications for transparent techniques, but there is no reason why it should not be adapted to opaque techniques. You might, for example, contrast an area of thinly spattered paint with one more evenly and heavily applied, or spatter a thin layer of color over a thicker base.

An old toothbrush is the implement most commonly used for spattering. You can also use a bristle brush, which makes a coarser spatter with larger droplets of paint. Or, for a really fine spatter over a large area, use a plant sprayer or a spray diffuser of the type sold for use with fixative. In this case you would need to mask any areas of the work that are to remain free of sprayed paint (see Masking on pages 64–65).

Whichever method you use, it is important to remember that spattered paint frequently lands in the wrong place—on your clothes, the floor and walls, and your work table—so it is essential to protect all vulnerable surfaces. Remember that acrylic is difficult or impossible to remove once dry.

The landscape in the picture above has been blocked in simply, with little detail in the foreground, as this was built up afterward with spattered paint.

GOUACHE SPATTER

Occasionally you will encounter an effect, such as the fine spray of windblown foam above a breaking wave, that is difficult to render in transparent watercolor. In this case, opaque white gouache spattered over dry watercolor can provide the answer.

1 White gouache spatter should be the final stage of a painting. Working over it will stir up the paint, sacrificing the effect. The paint needs to be mixed fairly thickly—too thin and it will sink into the watercolor washes. Always try the mixture first. If it goes wrong, you can remove the gouache, but this involves washing the entire area and beginning again.

2 Gouache, because it is thicker than watercolor, is easier to control, and you can place the spattered paint precisely. Hold the toothbrush a few inches from the paper, and run your thumb (or the handle of a paintbrush) quickly along the bristles.

3 Don't overdo the spatter; it is most effective when kept light, as in this example.

TEXTURING

Acrylic excels in the area of texture—there is almost nothing you cannot do with it. Textured effects can be created with the paint itself, by impasto techniques, knife painting, scraping techniques, and even extruded paint, to name but a few. You can also mix the paint with other materials, such as sand, sawdust, or one of the texturing mediums, or you can apply textures and paint over them.

Acrylic modeling paste, which is specially made for underlying textures—though it can also be mixed with the paint—can be applied to the painting surface in any way you choose, but you must use it on a rigid surface; if applied to canvas it will crack. You can create rough, random textures by putting the paste on with a palette knife. You can comb it on to make straight or wavy lines, or dab it on with a rag or stiff brush. And you can make regular or scattered patterns by imprinting—spreading the area with modeling paste and pressing objects into it while it is still wet.

Overall imprints can be produced with crumpled foil or a stiff brush, or you could achieve recognizable patterns with a flat embossed item, such as a coin.

In general, texture should be used creatively rather than literally, so these methods are better suited to work with a decorative or semi-abstract quality than to representational painting. Trying to mimic texture in a visual subject does not always work well, though you might use texturing in an urban scene, for example, to suggest rough stone walls or brickwork.

Experimentation is part of learning to paint, and it is always worth trying different methods of creating texture. Make up a series of samples like the ones shown on the opposite page.

ALUMINUM FOIL
A piece of crumpled foil pressed into wet texture paste (above) produces a coarse, stippled surface.

Paint mixed with sand. Using a dull red or gray, this grainy texture could imitate old brick or stonework.

Bubblewrap pressed into paint creates an even texture, which could bring interest into the background of a still life.

Fabric, such as terrycloth, pressed into thick paint gives a less obtrusive texture. This is ideal for actual fabric in a portrait.

Combing or scratching into paint can create a variety of effects. These could suggest trees or grasses blown in the wind.

Crushed eggshells stuck down with gloss medium and painted over. Use for the foreground of a stony beach.

Coins pressed into acrylic modeling paste and painted with transparent paint. This look could contrast with flatter paint in a semi-abstract work.

UNDERDRAWING

It is not essential to draw before you paint. Some artists are content with a few pencil lines or marks drawn with a brush to give the main placings of the subject. However, unless you are very experienced and know exactly how you are going to organize your composition, it is wise to draw first, particularly if your subject is at all complicated or involves hard-to-draw elements such as figures.

If you are using opaque techniques, the paint will completely cover your drawing, so you can draw in whatever medium you like—pencil, charcoal, or a brush and thinned paint. It may be best to avoid charcoal if you intend to start with pale colors, as it can muddy them slightly—some artists like this effect, while others prefer to keep the colors pure from the outset.

Transparent techniques need more planning. You can't paint over mistakes without losing the transparency, so you must have a good drawing. Heavy lines, though, may show through the washes, particularly in very light areas. This may not matter because pencil lines can combine well with watercolor effects, but it could be crucial. For example, if you are painting a seascape and have drawn a horizon line which you later decide to lower, you will have a pencil line showing through an area of sky. You can't erase it, as the plastic coat formed by the paint will have sealed it in place. So keep the lines as light as possible, avoid shading, and don't start to paint until you are sure the drawing is correct.

In this underdrawing the artist has used charcoal and cerulean blue to make a rapid sketch of her subject. The background is indicated in black and white and the flesh tones in yellow ochre and yellow. The drawing is then developed in cadmium yellow and bright orange. These vivid colors are used to describe the figure and develop the form.

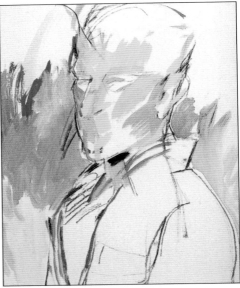

UNDERPAINTING

Before the Impressionists revolutionized oil painting techniques by working outdoors directly from the subject, the usual practice was to paint in the studio from sketches and preliminary studies. Paintings were built up in layers, starting with a tonal underpainting—usually brown—which established the whole composition and all the modeling of forms. Color was applied in the final stages.

With oils this is a laborious process, as each layer must be dry before the next is applied, but fast-drying acrylic is ideal for such techniques. Some oil painters work over an acrylic underpainting and some acrylic painters have revived traditional oil techniques by building up a whole picture in thin layers of glazing over an underpainting.

This method is only suited to studio work, but for any large or complex composition, such as a figure group or highly organized still life, it can be more useful than underdrawing (see page 77) because it allows you to work out the main light and dark areas.

Sometimes areas of the underpainting are allowed to show through in the finished work, so the color must be chosen carefully, as with a colored ground. You can make a monochrome underpainting in shades of one color to contrast or tone with the overall color scheme, or one in shades of gray. However, in the latter case, if you intend to apply the colors thinly, you run the risk of losing color purity. This could work very well for a low-key color scheme, however.

A gray underpainting, made by thinning black paint with varying amounts of water, establishes the tonal structure of the composition.

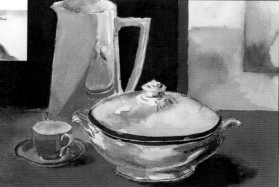

Again, some areas are left white or pale gray to avoid muddying the translucent, watercolorlike washes. The dark gray used for the background gives strength to the red-brown laid on top.

WAX RESIST

Wax resist is a technique that relies on the incompatibility of oil and water. Like masking, it blocks the paint from certain areas of the picture, but the effects it creates are quite different.

The basic method is simplicity itself: A candle or any waxy crayon is used to scribble over clean paper, and a wash of water-thinned acrylic is laid on top. The paint slides off the waxed areas, leaving a slightly speckled area of white.

Watercolor painters often use the technique to suggest clouds, waves, or ripples in water, or the textures of cliffs and stone walls, but it has many other possibilities, and is particularly good for mixed-media work, such as ink and acrylic.

You are not limited to a white candle or crayon; you can use colored wax-oil pastels, or the newer oil bars, which are excellent for wax resist, making a drawing in several colors which is then overlaid with a contrasting color of paint. You can even build up a whole picture by means of a layering technique, scraping or scratching into the wax before putting on more paint (or perhaps ink), then adding further wax and so on. If you try this, work on tough paper or you may damage the surface. And remember to keep the paint well-thinned—if it is too opaque it may cover the wax completely.

1 Watercolor paper was tinted with colored gesso, which provides a slight texture and reduces the flare of white paper. A pencil drawing was then made as a guide and wax applied lightly to the top of the cabbage.

2 The thin, watered paint slides off the wax. Thick paint is less suitable for this method, as the tough plastic skin formed by opaque acrylic can cover the wax completely.

3 Further drawing is done with the sharpened end of a household candle. The colored ground helps the artist to see where she is putting the wax; this can be a rather hit-and-miss affair on white paper.

4 Another application of paint builds up the texture, with the paint creating a series of tiny dots, blobs, and dribbles as it slips off the wax and settles in the nonwaxed areas.

5 To create more precise, linear effects, the point of a knife is used to scratch away the small drops of paint that have settled on top of the wax. The artist has turned the board around to gain access to this area of the picture.

6 A white oil bar is now used to draw over the paint, giving more definition to the cabbage leaf, which was previously rather amorphous. The bar has also been used to reinforce the drawing in the center of the cabbage.

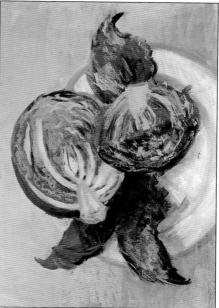

7 The finished picture shows a lively combination of pattern and texture. The oil bar, which has been used both on the cabbage and the plate, gives a painterly quality to the image.

Mixed Media

Acrylic lends itself to mixed media work more than any other artists' medium. Apart from being able to combine with different substances and materials to get a whole range of textures and surface patterns, it can also be used with pastel, ink, watercolor, and gouache, and with many drawing materials such as pencil, crayon, Conté crayon, chalk, and charcoal.

Illustrators often combine acrylic with another medium, sometimes painting a realistic image over a random background of tissue paper collage, sometimes using the acrylic to block in lively areas of local color and then drawing a detailed image over this with pencil, charcoal, pastel, or pen and ink. Combinations such as these keep a picture alive and interesting and often reproduce better than an illustration done in opaque paint only.

Often regarded as a modern rival to oil paint, acrylic can also be extremely helpful to oil painters, complementing rather than competing with the oil colors. Because oil paint can be safely applied to an acrylic surface, it is possible to use acrylic for the first stages of a painting—the initial "blocking-in" of the main areas—and to continue the picture in oil.

This can save a lot of time, because normally an artist has to wait until the blocking-in is dry enough to be worked over. With oil paint this can be several days, but if the first basic underpainting is done in acrylic, the paint is normally dry enough to be painted over almost immediately. The artist can then use oils for the final stage, when the slow-drying colors can be worked and moved around over a longer period of time, to make final adjustments to tone, color, and detail.

It is important to remember that acrylic cannot be used over oil paint in the same way. Even if the paint appears to be going on normally, an oily or greasy surface will eventually repel acrylic, and your painting will be short-lived.

Sculptors and craftsmen are also discovering the advantages of acrylic and acrylic mediums. It is the natural color for much of the plastic and fiberglass materials now used in three-dimensional art, although it can be used equally well on metal, wood, and masonry. It is especially useful if the work is to go outdoors, when a weatherproof paint is essential.

GOUACHE

Acrylic and gouache paints work well together because of their versatility. Gouache can be used thickly or diluted with water to create semi-transparent washes.

ACRYLIC AND CHARCOAL

Some acrylic paints can be used thinly on paper, very much like watercolor or gouache paint. It follows that you can combine them with any drawing medium you would normally use on paper.

Charcoal is in itself a versatile medium, capable of producing both fine lines and rich areas of tone. By combining it with acrylic you can achieve a wide range of exciting effects.

There are many different ways of working. For a portrait you might map out the composition with charcoal, using it also to block in the background, then paint the face and head before working more charcoal into this. For a landscape you might begin with loose overall washes of color and then use charcoal to define details and build up areas of darker tone.

In any mixed-media work it is important to think in terms of a marriage—the media should blend together while retaining their separate identities. Charcoal has a matte surface, so unless you have a reason for aiming at textural contrast it is probably best to keep the paint matte also, thinning it with water rather than with a medium.

1 The artist begins with loose washes of color, keeping the paint fairly thin so that he can draw over it with charcoal. He is working on watercolor paper.

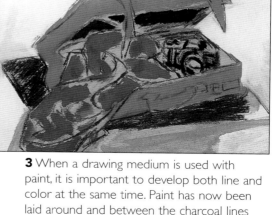

2 A stick of thick charcoal is used to draw over and into the paint, gradually building up the definition.

3 When a drawing medium is used with paint, it is important to develop both line and color at the same time. Paint has now been laid around and between the charcoal lines on the patterned fabric.

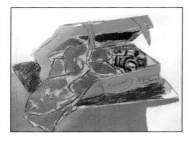

mouth diffuser

4 With the paint still wet, the whole left side of the picture has been sprayed with water, using a mouth diffuser. A spray bottle filled with water can do the same job.

5 In this detail you can see the effect of the water spray, which has created a soft, granular texture. The paper was allowed to dry before the artist continued working into the paint with charcoal.

6 When the charcoal drawing on the fabric is complete, a small bristle brush is used to dab in touches of magenta. This brilliant color provides a balance for the hot color of the suitcase, which might otherwise have been too dominant.

7 Finishing touches were the addition of highlights on the metal fittings of the suitcase and some further charcoal drawing on the table.

GOUACHE AND CHARCOAL

In this painting, the initial drawing was made in charcoal. The soft, dusty black creates a strong structure for the work and is easy to correct or overpaint. Keep the charcoal drawing clean, or the fine black powder will mix into the paint and deaden the colors. Lay in thin colors at the start to establish general tones and then work over each shape to revise the colors and build up the pattern.

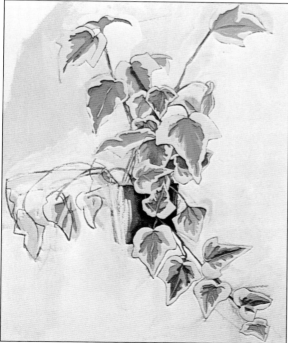

Charcoal was used to outline the shapes of the leaves and the stalks in this painting of ivy. After brushing away the excess charcoal dust from the surface of the drawing, the artist used a small sable brush, working directly over the sketch and blocking in tones.

INK AND ACRYLIC

These two media are natural partners and are particularly suitable for transparent techniques on paper. Colored drawing inks (some of which are water-soluble and others shellac- or acrylic-based) are transparent and have considerable depth of color, so they can be used to reinforce washes of transparent acrylic color.

Black drawing inks (sometimes called India inks) are thicker and more opaque. These can be used in line and wash techniques with thin acrylic, or painted on with a brush either over acrylic colors or side by side with them. Brush drawing in black ink makes a very positive statement, so this approach is best suited to bold work, with strong areas of color complementing the dense blacks.

You can also exploit the differences between media by using the acrylics opaquely in combination with transparent colored inks. As in all mixed-media work, there is no fixed way of working; experiment will show the method that works best for you.

1 Because the subject is quite a complex one, the artist first made an underdrawing before putting on the color. She then uses a combination of black ink and paint, pushing the paint around on the surface with her fingers. The ink she has chosen is an acrylic-based one called "liquid acrylic," which is made in a range of colors.

2 Yellow ink is now applied directly from the dropper. A brush or pen can also be used, but the dropper gives a free, impressionistic effect similar to this artist's style.

4 In this detail you can see the different surface textures achieved by combining inks with thicker applications of paint. Ink has been used for the purple boat and the black one in the foreground, with brush strokes of paint overlaying the ink in places.

3 She wants a loose effect in the sky also, so she uses a slightly dampened rag to spread marks made with water-soluble crayon. The smoothness of the paper makes it easier to move color around in this way.

5 Again using ink straight from the dropper, a small, irregularly shaped mark is made to suggest a boat in the background of the picture and echo the reds of the foreground boats.

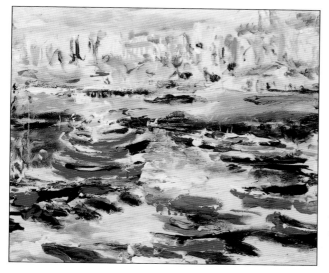

6 Throughout, there has been no attempt at literal description. None of the boats or other features have been dealt with in detail, but the painting successfully conveys the atmosphere of a harbor, with all its color and movement.

ACRYLIC AND GOUACHE

The artist used gouache as well as acrylic in this picture. These two types of paint are compatible. The difference between them is that when acrylic is laid down it cannot be dissolved (unlike gouache and watercolor, which can be manipulated with water even after they have dried). Acrylic, therefore, is very useful for the monochrome underpainting technique. It dries as quickly as gouache, and gives a stable undercoat on which the color can be applied. The artist can manipulate the gouache with water, moving it around and blending it, but the acrylic beneath will not be affected. Thus the artist can work in genuine stages. If the acrylic

1 In this painting the artist takes advantage of the quick-drying properties of acrylics by using them for the tonal underpainting before applying the top color in gouache. Acrylic does not dissolve once dry, and therefore provides a stable base for the water-soluble gouache. The acrylic underpainting, built up in thin layers of raw umber, will not mix with the wet gouache when it is applied—this would cause the final colors to turn muddy.

undercoating were to dissolve, the white and neutral color would soon make the top color very gray. This method keeps it pure.

2 Contrasting tones are introduced into the underpainting, above. Deep, opaque color indicates the dark shadows behind the model, and white acrylic is introduced into the lighter areas. This underlayer of bright white will produce luminous, semitransparent colors when thin layers of gouache are applied over it.

PASTEL AND ACRYLIC

Like many mixed-media techniques, a combination of pastel and acrylic can either exploit the differences between the component media or unite them into a homogeneous whole.

An example of the latter approach is the technique employed by some pastel artists of making an acrylic underpainting. Sometimes the whole of this is worked over in pastel, and sometimes parts are left as they are. Because it is difficult to cover an entire surface with pastel strokes, this practice avoids the possibly distracting effect of white paper showing where coverage of pastel is light. It is also a means of achieving broken color and color contrasts—small areas of, say, a blue underpainting showing through an application of red or purple pastel can create wonderfully vibrant effects.

Sharper media contrasts can be achieved by starting with acrylic thinned to a watercolor consistency and drawing on top with pastel or oil pastel. In such cases it is probably best to relegate the pastel to a secondary role, using it perhaps only to define an area of pattern or enhance some detail.

However, the two media can also be used hand in hand. Both acrylic paint and acrylic matte or gloss mediums are excellent fixatives for pastel, so you can build up a painting by a layering method: applying some paint and pastel, then covering the pastel with medium or paint and laying on more. Wet paint or medium can cause the pastel color to spread slightly, but this gives a watercolor effect at the edge of each stroke, which can be very attractive.

1 The composition was first sketched out in soft pastel, using a combination of linear strokes and side strokes—those made with the side of a short length of pastel. A transparent wash of water-thinned paint is brushed lightly over the pastel. Because the paint forms a plastic skin, it fixes the pastel, allowing the artist to work on top with no risk of smudging.

2 Further washes are now laid over the background area. The artist develops the two media together, so that the painting has a unity of technique from the outset.

3 The artist continues to build up the painting with both paint and pastel. Because the watercolor paper has a slightly rough surface, it breaks up the pastel marks to provide a broken color effect.

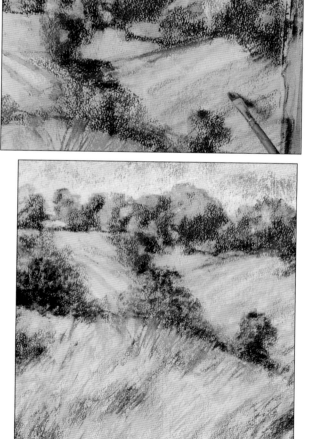

4 The finished painting is a good example of a successful marriage of media. Although there is a contrast of textures, no one area can be singled out as being either paint or pastel.

PENCIL AND ACRYLIC

Pencil can be used under washes of acrylic color or on top of paint that is transparent or opaque (see opaque techniques and transparent techniques).

If you want a strong contrast between paint and line, try using pencil for one part of an image and paint for others. This device is sometimes used by illustrators, who deliberately exploit media contrasts and juxtapose areas of color and monochrome in order to achieve an impact from the unexpected.

However, you need sure intentions and a degree of skill for this kind of work, so it is probably best initially to employ the two media in a more integrated way. If you are using transparent techniques, one of the problems inherent in acrylics can be turned to advantage. For watercolors and for watercolor effects in acrylic you need a good underdrawing. In actual watercolor work, this can be erased after the first washes are in place, but this is not possible with acrylic, which acts as a fixative on the drawing. So try making the drawing a part of the picture from the start, laying colors over and around pencil

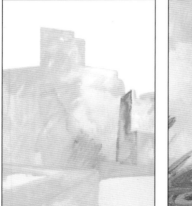 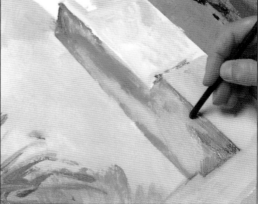

1 The shape of the building is blocked in with thin paint. A smooth-surfaced paper is used. Less absorbent than watercolor paper, it doesn't even out the paint as much, allowing the brush strokes to play a part in the composition.

2 The artist begins to draw into the paint as soon as it is dry, using a graphite stick—a pencil without the usual wooden casing. The artist then applies a loose blue wash for the sky, and defines the details at the top of the tower.

lines and adding pencil as the picture takes shape.

Opaque paint will, of course, obscure your original drawing, but you can still use pencil on top. How much you use and in what way depends on the effect you want: You might reserve the pencil drawing for small areas of detail or pattern, or for parts of the picture that are easier to draw than to paint, such as flowers, stems, the edges of leaves, or facial features. A soft pencil is also excellent for shading to model forms, which can be tricky in acrylic because of the fast drying time.

3 The shapes of the palm leaves have been built up with a combination of brush strokes and graphite drawing. Now a small brush is used to pick out some highlights with pale blue-gray paint.

4 Touches of drawing suggest the rough stonework, and the graphite stick comes into play again for the shadows below the small outgrowths of shrub.

5 In the final stages, more graphite drawing was done on the building, giving an accurate impression of the textures of the old plaster and stonework. The drawing, the light colors, and the free brushwork in the sky all contribute to the atmosphere.

WATERCOLOR AND ACRYLIC

We have already seen some of the advantages and disadvantages of using acrylic as a substitute for watercolor. Acrylic can also be used hand-in-hand with watercolor, which is perhaps a more satisfactory way of working, as it allows you to use both media to the best advantage.

Watercolor painters often use a touch of "body color" (opaque paint) here and there, perhaps to sharpen a foreground, to add white highlights, or simply to correct a mistake. Usually gouache paint is used, or Chinese white mixed with watercolor, but acrylic is a better choice than either of these, as it does not give such a matte, dead surface.

Paintings that are officially classified as watercolor frequently include acrylic, and if the acrylic is used skillfully it is often impossible to tell which is which. The trick is to reserve the pure watercolor for any areas that need its particular translucent quality, and to use the acrylic fairly thinly—it should be capable of covering colors below but should not stand out from the surface. In a landscape with grass and trees in the foreground, for example, you would use pure watercolor for the sky and the far distance, and acrylic—either on its own or over watercolor washes—for the foreground and perhaps any areas of texture in the middle distance, such as a wall or group of houses.

Because the slightly thicker paint has more physical presence than the thin watercolor, it will tend to come forward to the front of the picture. This allows you not only to describe foreground detail and texture (always difficult in watercolor) but also to accentuate the sense of space.

VIEW OVER ULLSWATER by Hazel Harrison
Acrylic was used only for the problem areas of foreground and tree, both of which lacked definition. The effect is very similar to that of watercolor thickened with white gouache, but the artist is accustomed to working in acrylic and finds it easier to handle.

WATERCOLOR AND GOUACHE

CORN MARIGOLDS
by Jean Canter SGFA
Watercolor with a little white gouache. The oval format chosen for this delightful study gives it a rather Victorian flavor. The artist has created a strong feeling of life and movement, with the sinuously curving stems and leaves seeming to grow outward toward the boundary of the frame.

WATERLILIES by Norma Jamieson RBA, ROI

Gouache and watercolor on coarse drawing paper. Jamieson works partly from life and partly from transparencies and says that the former gives the necessary element of spontaneity to her work while the photographic studies provide the equally necessary time for consideration. For specific flower forms, she takes numerous slides, from different angles and positions and in close-up, using the camera like a sketchbook and then distilling what interests her most when she begins to paint.

Making Changes

One of the great attractions of opaque acrylic is that it allows for drastic alterations at each stage in the working process, and therefore gives you the freedom to try out different compositional ideas and color combinations. If you decide that there are too many objects in a still life, you can paint one or two of them out. If the sky does not work well with the other colors in a landscape, you can paint over it with opaque color or lay a transparent glaze on top to modify the hue. Glazing is a quick and easy way of adjusting color balances within a painting.

When the paint is used at medium consistency, you may find that a new paint application does not completely cover what is beneath. Some colors, such as crimson and ultramarine blue, are relatively transparent unless mixed with white. In such cases, paint over the offending area with unthinned white paint or acrylic gesso and let it dry before applying the new color.

In watercolor mode, you cannot make major changes, such as painting an item out or changing a shape, unless you are prepared to sacrifice the translucent effect by overpainting with opaque paint. However, opaque white can safely be used to redefine or emphasize highlights. Watercolor painters often use touches of white gouache to create similar effects.

Altering colors by glazing
This photograph shows the painting divided into four sections, three that have glazes in different transparent colors, using paint diluted with water alone. Try out your glaze first on a piece of spare paper.

The yellow glaze slightly intensifies the original greens and gives a green tinge to the blue stripes of the pitcher.

This area was left unglazed to compare with the yellow-glazed area on the left.

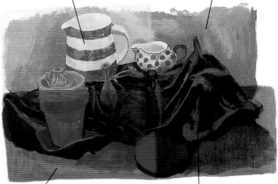

The red glaze has a powerful effect, turning the purple cloth a red-magenta color and the pot a rich red-orange.

The blue glaze also changes the colors radically. The purple cloth is now almost pure blue, and the red pot lid is purplish, and much darker in tone.

COMPOSITIONAL CHANGES

1 One of the leaves of the leek was painted out and another was introduced higher up. A layer of white is painted over with yellow-green.

2 All traces of the original leaf are removed using the same red background color as before, and also using the paint at the same oil paint consistency.

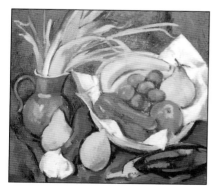

TAKING PRECAUTIONS

Take precautions to avoid unnecessary corrections. Start with an under-drawing and be sure it is right before you put on the paint. If your subject includes straight edges, paint against the edge of a plastic ruler.

CORRECTING ERRORS

1 Symmetrical shapes often cause problems, and this vase is lopsided. The edge of the vase is redefined by laying the light blue-gray background color firmly around it.

2 The edge was also too hard, failing to give an impression of form, so some light gray is applied to blur the edge and merge it into the background.

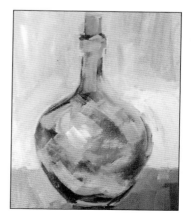

95

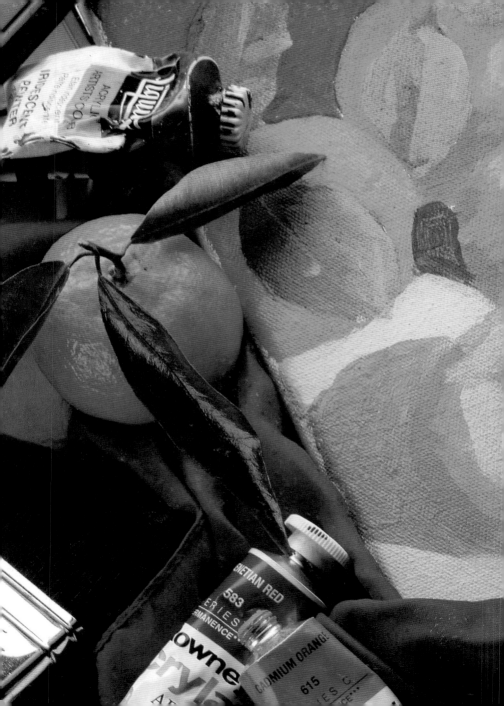

Color and Composition

When you produce a painting, a number of different influences affect your interpretation of the subject, but perhaps the most important are the paint texture and color range of the medium that you use. These create the character of the picture, so that the viewer, who has probably never seen the original inspiration, judges the painting on its own terms.

Composition creates order out of the visual anarchy of everything we see around us. It is the way in which the artist takes a firm hold of the pictorial world and sets it into a particular context and arrangement. It can transform the painter into an active performer, rather than just being a passive recorder of visual data.

The Geometry of Composition

Unless you have made a deliberate choice to do otherwise, it is almost always advisable to avoid a totally symmetrical composition. Once the picture is equally divided, either horizontally or vertically, it is extremely difficult to complete the picture so that it is not unnatural and uncomfortable to look at. Occasionally one sees a landscape or still life where the horizon or the background cuts the painting into separate halves, but where this has succeeded, the artist has generally compensated for the symmetry elsewhere in the composition or—less often—used the equal sections as a positive aspect of the picture.

A successful composition depends on the artist's ability to see the subject in broad, abstract terms. In order to do this, it is necessary to cut out all the details and to concentrate initially on the main structures and shapes that hold the composition together. If these are established in a satisfactory way, the rest of the picture will fall into place naturally.

It is a good idea to make several sketches—each one simplified into an arrangement of geometric shapes—before committing your final composition to the canvas. In this way you will be able to see immediately what the various possibilities are, choosing your basic composition from the sketches in front of you rather than relying on

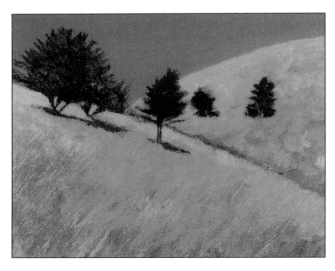

NORTH HILL, TREES
by Paul Powis
This painting derives its impact from the way the artist reduced the scene to its bare bones, basing his composition on strong contrasts of tone and of the interplay of simple shapes. The three key shapes are those of the sky and the two hills, separated by the path.

your first attempt—which won't necessarily be the best one.

Traditionally, a good composition is one that manages to hold the viewer's attention within the main picture area. The best way of achieving this is to imagine an oval shape within your rectangular canvas—or a circle, if your painting happens to be a square one. By keeping all the main activity within this oval, the viewer's eye will not be led out of the picture but will stay comfortably within the central shape. Of course, any obviously discordant element in the composition, such as a figure facing or pointing toward the edge of the picture, will inevitably lead the eye directly out of the composition, whether it is placed in the central oval or not.

CROPPING

The close-up view provides a strong composition based on two intersecting triangles, the pale one of the face and the darker one of the background.

The foreground tree trunks balance the verticals of building and reflections. Cropping them at top and bottom brings them forward in space.

Cropping the tops of the flowers focuses attention on the central blooms, the vase, and its shadow.

Sometimes a composition is improved by cropping, which means allowing part of the subject to go out of the frame. Tall trees in the foreground of a landscape, for example, could extend from top to bottom of the picture. This would stress the spatial relationships, because cropping foreground elements brings them firmly to the front of the picture plane to act as a frame within the frame for the landscape beyond. Cropping is a useful compositional device for flower paintings, too.

Unity and Balance

There are no unbreakable rules about composition, but there are some guidelines. Aim for a good balance of shapes, colors, and tones, so that there is interest in every part of the picture. Try to set up visual links that bind all the elements together into a unified whole. You can do this through color, but you can also arrange the shapes so that they establish harmonious visual relationships. A dark clump of trees in the middle distance might be balanced by a shrub nearer the front

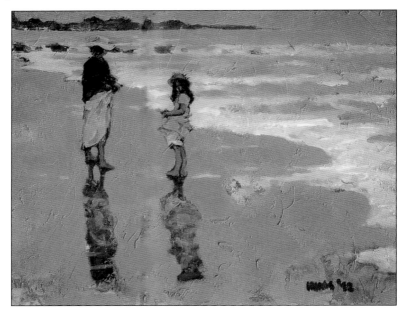

TWO ON THE WET SAND by W. Joe Innis.
To avoid possible monotony of color, the artist worked on a pinkish ground, allowing patches of this warm color to show through the cool blues and blue-greens and form a link with the skin tones of the figures.

of the picture, creating a link between the two.

Avoid making your composition too symmetrical. Dividing the picture into equal areas of sky and land, for example, produces a disjointed effect. Nor is it wise to place some dominant feature directly in the center, because this makes a dull and static composition.

THE GOLDEN SECTION

One time-honored method of working out a composition is to use what is known as the Golden Section. This technique divides a rectangular shape into what are generally considered to be the most harmonious and satisfying proportions possible.

The concept of the Golden Section, which has been recognized for at least 2,000 years, holds that the most harmonious relationship between unequal parts of the same rectangle is achieved if the smaller section is in the same proportion to the larger section as the larger section is to the whole.

No one knows exactly why this particular division works, but it has been used repeatedly throughout the history of civilized art, and the same proportion occurs naturally in many of the organic structures found in plants and simple animal life. The number of paintings that are based on the Golden Section is surprisingly large, particularly considering that many of the artists who painted them were unaware of this concept at the time.

The Golden Section division is worked out geometrically, although most artists do not go to such lengths, preferring their decisions to be visual rather than mathematical. Even so, the majority of their paintings will contain the Golden Section somewhere in the composition. Generally it is better to be guided by your own eye and instinct than to feel bound by a theory that will probably inhibit rather than help your composition, but the Golden Section can sometimes be a useful starting point if you are stuck for an idea or don't know where to begin.

There are, in fact, no rigid rules about what makes a good or bad composition—and what is suitable for one painter might be quite inappropriate for another. The most important thing is to be aware of what you are doing and why you are doing it, and to carry out your decision with confidence. No one knows better than yourself what interests you about a particular subject or how to arrange that subject on the canvas.

TO FIND THE GOLDEN SECTION, see right, draw a square ABCD. Divide DC equally at E. Starting at E, construct an arc through B. Extend DC to meet the arc at G. Construct rectangle ADGF.

Choosing a Viewpoint

Painting is a continual process of making decisions, both at the painting stage and before. Your first decisions concern not only what to paint but from what viewpoint. It is surprising how radically a change of viewpoint can alter a subject, even if all you do is to raise or lower your own eye level. A low viewpoint makes the foreground more dominant; in fact, a tall foreground feature can block your view of the distance. In still life, looking down on the subject can provide a better composition than viewing it at eye level. A high viewpoint organizes the elements into a pattern.

A lower viewpoint would have reduced the amount of sea visible, and the heads of the figures would have jutted into the sky, making the composition less satisfactory.

The verticals of the reflections, created with light downward brush strokes, counterpoint the dominant horizontals.

The angle of viewing has a direct effect on how you perceive the spatial relationships of objects. Trees in a landscape may overlap and therefore be difficult to read when viewed from one angle, but if you move to the right or left they will separate out. Spend some time exploring viewpoints, using the viewfinder system shown below to frame the subject in different ways. If you are taking photographs to paint from, you will, of course, use the camera's built-in viewfinder.

EMPHASIZING THE FOREGROUND
The artist decided to place the figures at a distance, choosing a viewpoint that allowed him to make the most of the glistening expanse of wet sand in the foreground. He worked from a standing position, with his head at roughly the same level as the figures.

EMPHASIZING PATTERN
The high viewpoint chosen for this still life emphasizes the flat-pattern element and the contrast of shapes. Notice how the shadows beneath, beside, and within the objects are treated as shapes in their own right, and stressed by sharp divisions between light and middle tones, so that they contribute to the overall pattern.

NEAR AND FAR

A viewfinder (see examples below) will help you to decide which part of the subject to focus on and how much of it to include. For example, do you want to bring a group of trees in the middle distance nearer by reducing the amount of foreground, or push it back with a wide expanse of foreground? How much of the background do you want to include in a portrait or still life? Hold the viewfinder at different distances from your eye; the farther it is from you, the nearer the subject will appear. If you have no viewfinder, use your hands, joining thumbs and index fingers to make a rough rectangle.

The shadows and light areas create their own pattern.

A traditional landscape format accommodates the group of middleground trees and the sweep of the path leading in from the foreground.

An upright rectangle shows less of the trees, but allows for the introduction of dark tones in the foreground to balance them.

An adjustable viewfinder is made by cutting two L shapes of cardboard, which you can slide over one another, turning a horizontal rectangle into an upright one or a square. The cardboard should be black or gray rather than white.

CHOOSING THE FORMAT

When you have chosen your viewpoint, select the format for your painting. The majority of landscapes have a horizontal emphasis, but for certain subjects, such as a group of tall trees, an upright shape might be better.

The Focal Point

It is not essential for paintings to have a center of interest, or focal point, but many do. Often this arises directly from the subject. When you choose a landscape to paint you may do so because you are attracted by some dominant feature, such as a building in the middle distance, and this will automatically become the focal point. In a full-length portrait, the natural focal point is the face, and in a head-and-shoulders portrait it is the eyes. But sometimes you will need to determine the focal point yourself. In a still life, for example, you could emphasize one object through color or tonal contrast.

At one level, the painting can be read as an abstract arrangement of shapes, with the elongated curve setting the key for the composition. Notice how the negative shapes of the pale water in the foreground play as important a part as the positive reflections themselves.

DAWN AT THE BOATWORKS by W. Joe Innis

TONES AND SHAPES
The strong tonal contrasts in the center of the picture, emphasized by the dark background, draw our eyes to the figures in the boat. But equally important is the way the shapes are orchestrated. The diagonal in the foreground leads to the curving side of the gray boat, and then to the long, elegant shape of the rowboat.

This finds an echo in the less obvious curves of the figures and their reflections, and is contrasted with the horizontal lines of the ripples behind.

PLACING THE FOCAL POINT
Where you place the focal point in spatial terms depends upon how much space you are dealing with. In

landscape, it is traditionally placed in the middle distance, which has the effect of leading the viewer's eye into the scene. A good painting should invite the viewer to participate.

Remember the rule of asymmetry and do not put the focal point in the center of the picture. This would make it too obvious, and the eye would travel straight to it instead of journeying around the picture from one area to another.

LEADING THE EYE

You want to draw attention to the focal point—that is why it is there—but to do so subtly, through a system of visual signposts. Our eyes naturally follow diagonal or curving lines, and these are often used to lead toward a center of interest. In landscape, they can take the form of a path or river running in from the foreground. In a still life or flower group, folds of drapery could serve the same function.

Although the focal point is not emphasized, our eyes are led into and around the picture, from the group of figures on the right to those on the left and then to the bandstand. The light shape between the trees leads down again from the top of the picture.

BANDSTAND AT GREENWICH PARK by John Rosser

PLAYING IT DOWN

While the focal point was stressed in the painting opposite, here it was played down. In a landscape, human-made features, such as buildings, always stand out against natural ones, and they risk becoming overly prominent. The pretty bandstand is the focal point, both because it is human-made and because it is the theme of the picture. But the artist's main interest was in capturing the carefree atmosphere of a sunny afternoon in the park. He therefore treated the bandstand delicately, so that it blends with the background trees and foreground figures. The use of repeated colors, with yellows and blues appearing throughout the picture, ensures compositional unity.

The Tonal Picture

Tone plays an important part in any picture. It is seldom sufficient to arrange the subject as a series of related shapes, however satisfactory this linear arrangement might be. Unless you pay proper attention to the light and dark tones of those shapes, the subject is likely to lack form or any illusion of three-dimensional space, and a flat, uninteresting composition could be the result.

Every color has a tone. Pale colors, for example, are tonally light, and if you were planning the tonal patterns in a composition of flat shapes, they would be represented as very light grays. Should you be painting a still life that included a pale vase, however, the color could not be interpreted as a single light tone. Light and shadow create their own tones, and the local color of the base would probably play a very small

COMPOSITION

The three paintings, above, are open compositions, in that the figures could almost walk right out of the picture.

In contrast, the cozily designed scene right is a closed composition, with the focal point enclosed in the picture.

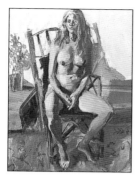

TONE

The tones of a painting are as important as its composition and color. Before embarking on the painting above, the artist first made a black and white sketch right, in which the tonal design of the composition was worked out.

part in the tonal composition compared with the contrasting light and shadow tones caused by light falling on the vase.

Although a subject is intrinsically light or dark—and these local tones should not be overlooked when considering the overall abstract design of a picture—it is those tones created by light falling on the subject that are more important in most realistic paintings in which the illusion of three-dimensional form is crucial.

In the same way that tone describes form, it can also be used to create space. By accurately rendering the tonal variations of objects receding into the distance, for instance, you will capture the atmospheric haziness, or aerial perspective of three-dimensional space.

Careful and accurate representation of tonal values, therefore, is essential in any painting where a sense of three-dimensional reality is important. It is advisable to think about this tonal content in the very early stages of your painting and to plan your initial composition not only in line but also in broad areas of relative light and shade.

Tonal Structure

Just as the colors in a painting must work together, so must the tones. A painting needs an overall tonal structure, in which the lights and darks balance and counterpoint one another, forming a pattern that is independent of the colors used. Look at some black and white reproductions of pictures by professional artists to see how this aspect of painting works at its best.

CASTLE MORTON by Paul Powis
The darkest tones, in the foreground hedge, tree and shadow, are nowhere near the black end of the gray scale.

USING LIGHT TONES

A high-toned key was used here, which means that there are no really dark tones, yet there is enough contrast to make an interesting composition, and the subtle modulations of tones within each area—for example, the clumps of trees—describe the form clearly. The picture conveys an impression of shimmering heat, with the sun bleaching out the colors and reducing contrast. In landscape painting, it is important to judge tones as well as colors accurately, because it is through both of these aspects of your painting that you express the quality of light that is inherent to any outdoor scene.

RELATIVE VALUES

Like colors, tones must be judged one against the other rather than being viewed in isolation; something looks dark qnly because a neighboring thing is lighter. It helps to work on a mid-toned colored ground, which gives you a basis against which to assess the darker and lighter tones. If you are using a white surface, do not begin with the lightest tones, because this may cause you to pitch the entire painting to high. Instead, block in the dark and middle tones first and work up to the lights. Make comparisons throughout the painting process.

HIGH AND LOW CONTRAST

You do not need heavily marked light-dark contrasts to achieve a tonal pattern, but there must be some contrast, or the picture will look flat and dull. The amount of contrast will depend upon your subject and the lighting conditions. Portraits are sometimes lit to provide dramatic contrasts of tone, but the majority of subjects seen under natural light are in the mid-toned range. This means that neither the lightest nor the darkest tones will approach the black or white end of the gray scale. A landscape seen under strong sunlight will have more tonal contrast than on an overcast day, but it will still contain no pure whites.

AFTER JEAN DE FLORETTE by Barrington Magee
The dark, upright shapes of the figures and vertical box are counterpointed by the middle- and light-toned horizontal bands in the background.

HIGH CONTRAST

This degree of tonal contrast would never be found in the real world because the prevailing light would modify the blacks of the garments, creating areas of middle to light gray. But this is not a realistic painting, and the artist used high contrast and hard-edged shapes to emphasize the strange immobility of the figures, giving them a curved quality similar to that of the foreground objects. Apart from the careful modeling of the faces, the painting is an exercise in two-dimensional pattern-making.

TONAL SKETCHES

Some artists like to plan the tonal structure before painting by making monochrome sketches. This is a useful exercise, and helps to concentrate the mind. Use a soft pencil (4B to 5B), or a brush and diluted drawing ink. Do not try to include every tone you can see, or the drawing will become muddled. Look only for the

main areas of light and dark and two or three middle tones.

Color and Tone

PICTURE-MAKING PRINCIPLES

Color plays a central role in identifying objects. You could paint a lemon in a flat overall yellow and everyone would recognize it through color and shape, but it would not be realistic, because it would lack solidity. This is where tone comes in. It is the light and dark variations of color, caused by the fall of light, that make objects appear three-dimensional.

The lemon looks almost like a cut-out shape, because the overall tonality is so much lighter than the background. The black and white photograph reveals a dark shadow on the underside that is only slightly lighter.

COMPARING TONES

To paint successfully, you must make a continuous series of comparisons and judgments. Instead of looking at an object or area in isolation, assess its tone against those of neighboring objects to decide whether it is lighter or darker overall, or lighter in some places and darker in others. Often you will find that objects with different local colors, such as yellow and purple, appear to have areas of common tone because the light produces strong variations.

The local color of the apple is darker than that of the lemon but lighter than the maroon background. The shiny surface reflects the dark maroon, causing dense shadows equal in tone to the red above the apple.

A color is always affected by its surroundings. In the four pairs of boxes, the color in the center of each pair is the same. When placed against different backgrounds, however, the colors actually look quite different.

TONE AND LOCAL COLOR

The actual color of the object, the one we describe it by, is called its local color. To give an accurate account of what you see, you must evaluate both the local color and the different tones that you will observe on the object. It is surprisingly difficult to judge tone, because we do not naturally see in terms of light and dark; our eyes are more receptive to color. Half-closing your eyes, which reduces the impact of the color and blurs detail, makes it easier to identify the tones.

Reproducing tones is not always a simple matter of making a color darker or lighter. Both the shadowed side of the object and the light-struck areas may depart from the local color. Yellow is always light in tone, and ceases to be yellow if darkened, so the shadowed side of a yellow fruit may be greenish or brownish. A tree seen in bright sunlight may be almost yellow in places, with deep blue-green or even purple shadows, and the local color may be visible only in small areas.

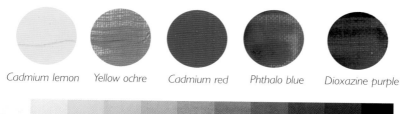

| Cadmium lemon | Yellow ochre | Cadmium red | Phthalo blue | Dioxazine purple |

USING A GRAY SCALE

A gray scale is a useful aid to judging tone. It will help you to learn the intrinsic tone of each of the colors in your palette and to assess the variations caused by light and shade. A common mistake is to overstate the darks. If you hold the scale up against a dark area in your painting, you may find that it is nowhere near the black end of the scale. Here you can see how the tube colors fit into a tonal scale, yellow near the top, and blue and purple near the bottom.

SHADOW COLORS

Most of the local color on a rounded object, such as these apples, is seen in the center. Shadow and highlight colors will depend upon the light that illuminates the objects and whether they are reflecting any color from nearby items. Here, the blue shadow cast by the apples is due not to reflected colors but to the strong, cold light.

CRACKED BOWL by William Roberts

The artist exaggerated the blueness of the shadows to maintain his cool color scheme.

Color and Mood

In addition to describing subjects we see in the world, color can be used expressively, to create a particular mood or atmosphere. Vivid colors and strong primary or complementary contrasts that call out tend to evoke a happy response. Dark heavy colors, such as browns, deep blues, and purples can be powerful in a different way, giving an impression of stability and thoughtfulness. A portrait painter might express something about the character of the sitter through color, choosing light, bright colors for a youthful subject and somber ones for a graver figure.

COLOR PERCEPTIONS

Colors have different associations for each of us, and these can vary. Red, for example, is the traditional color for warning signs. In some contexts it can be aggressive, but it can also be cheering. Blues, greens, grays, and pastel colors, the most usual choices for interior decor, are unassertive. A painting dominated by red is likely to draw attention more immediately than one using blue-green harmonies or light-toned neutrals.

HARMONIOUS COLORS

You can create a gentle atmosphere by avoiding contrasts and using harmonious colors, which are those close to one another on the color wheel. A landscape painting is likely to have this restful quality because the colors of nature are harmonious: greens from yellow-green through blue-green; skies comprising shades of blue and mauve. Flower painters often set up groups of harmonizing colors, such as mauves and pinks, or shades of yellow and orange, with perhaps one or two white blooms to provide tonal contrast.

HARMONY AND CONTRAST

Colors opposite one another on the color wheel set up dramatic contrasts. Adjacent colors are harmonious. In any section of the wheel, these form a related sequence.

PORTRAIT OF ARTIST'S
FATHER by Gerald Cains

USING DARK COLORS

The somber palette chosen for this portrait, together with the strong tonal contrasts and expressive brushwork, give the painting both atmosphere and drama. The colors are mainly darkened or lightened versions of the color wheel segment shown on the left.

USING BRIGHT COLORS

In contrast to the painting above, this still life conveys a joyous mood through the use of the primary colors shown below, and equally vivid secondary color mixtures—the green and the orange. The artist did not attempt a realistic depiction of this subject; the theme of the painting is color and pattern.

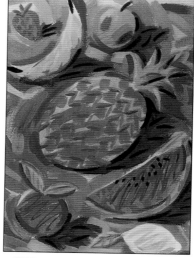

SUMMER FRUITS by Sara Hayward

COMPLEMENTARY COLOR CONTRASTS

Mixing the pairs of colors that are directly opposite each other on the color wheel produces neutrals. But when these colors are not mixed but juxtaposed, they strengthen each other, and the effect is vibrant. Artists often exploit complementary color contrasts, using violet for the shadows on yellow objects, placing small areas of red in green landscapes, or mixing blue and orange blooms in a flower painting. The colors need not be used at their full intensity; muted versions produce subtle but effective complementary contrasts.

Color Unity

In a good painting, all of the colors work together to create a unified image. A common mistake is to view each object or area separately. A painting that lacks an overall color strategy can appear disjointed or even create a discord like a wrong note in music. Choose which kind of colors you want—warm or cool, bright or muted—and then work at the entire picture all of the time rather than bringing one part to a higher stage of completion than others.

HEIGHTENING COLORS

This can often happen when you depart from strictly realistic color. Deliberately heightening colors is an exciting possibility, but if you do it, remember that no color exists in isolation. Intensifying the purple of a shadow, for example, will not work unless you establish the same intensity all over the picture. The purple shadow will look out of place among muted colors, so you would need to bring in other strong color notes to provide a balance; for example, vivid yellows in trees or fields and mauves and purples in the sky.

The creamy yellow of the sunlit clouds links with the yellow on the sides of the houses and the small flowers in the foreground.

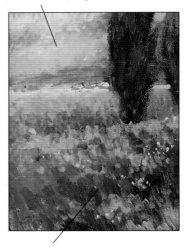

POPLAR BLUES by James Harvey Taylor. *Here the mauve-grays in the immediate foreground are repeated in the sky, and the muted reds suggesting flowers echo the distant rooftops.*

MUTING THE COLORS

The artist chose a scheme of cool, muted colors, which express the gentle feeling of this landscape. He carried them through the entire painting, repeating the blues and blue-grays of the trees in the foreground and in the sky. He rejected any vivid color accents; the foreground flowers, for example, were intentionally subdued. Although the contrasts of color and tone are not marked, this painting is lively and full of interest, with each part of the composition containing a number of different but closely related colors.

REPEATING COLORS

Whether you brighten the colors in this way or stick to naturalistic ones, you can link the various parts of the picture by using color echoes; that is, by repeating the same or similar colors from one area to another. Some landscape paintings are less than successful because the sky does not seem to relate to the land. Create color relationships by using touches of sky color among the greens of trees. If there are browns in the landscape, bring in browns on the undersides of clouds.

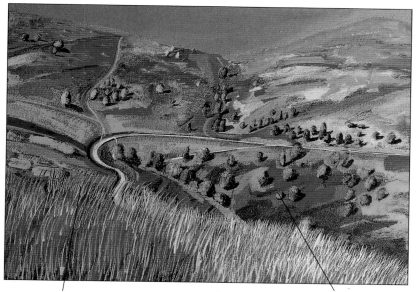

TOWARDS NORTH HILL by Paul Powis
Here any of the colors used in this area might look too bright if set against a neutral, but they work perfectly together.

This squiggling brush stroke of brilliant red does not describe any specific landscape feature; its purpose is to contrast with the turquoise and to echo the reds in the foreground and hills.

BRIGHTENING THE COLORS

This painting also has perfect unity of color. In this case the colors were heightened to give an impression of intense light and heat. Here, warm colors predominate, with reds, yellows, oranges, and mauve-blues offset by the cooler but equally vivid turquoise in the central area. As in the painting opposite, the artist brought the composition together with color echoes, repeating the yellows and reds from foreground to hills.

Creating Mood Inside

INTERIOR

You don't need to travel far and wide in order to find a suitable subject to paint; often the most interesting pictures are those that feature familiar objects and ordinary places. An interior scene, for example—perhaps the very room you are sitting in now—can provide an endless source of inspiration for the creative artist.

As with still lifes, you can arrange the objects in an interior, and also control the lighting, to express a particular mood or to make a personal statement. In this painting, for example, the artist has created a spare, almost abstract composition that captures the melancholy mood of a large, bare room on a cold winter's day. Through the window we catch a glimpse of the gray, wintry landscape beyond. The shadow of the window slants across the cold, empty wall. And in the corner stands a grand piano, half-hidden by a shroudlike dust sheet. Altogether, this is an atmospheric and thought-provoking composition.

To capture the mood of the scene, it was essential to work quickly before the light changed, and this is where the fast-drying properties of acrylics saved the day. The artist worked with a limited palette of neutral colors, and applied the paint directly onto the canvas with broad, flat washes.

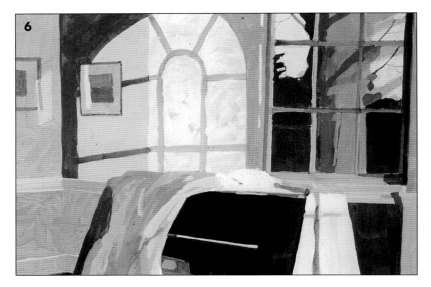

6

1 The artist begins by making an outline drawing of the subject on the support, using a B pencil. The pale tones of the wall are established first, using yellow ochre mixed with white, and lemon yellow in the lightest parts.

2 Using a No. 4 flat brush, the artist paints in the lines of the window frame, and its shadow cast on the wall, with raw sienna.

3 Now the dark tones of the foreground are blocked in with burnt umber darkened with black.

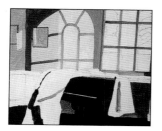

4 The artist paints "negatively," working the dark tones around the white shape of the dust sheet covering the piano. The folds in the dust sheet are indicated with strokes of burnt umber.

5 The shadows on the background wall and on the dust sheet are now built up using Payne's gray, cobalt blue, yellow ochre, and titanium white.

6 Finally, the scene outside the window is painted in, using Payne's gray, Mars black, burnt umber, and titanium white. Subtle, neutral colors have been used throughout, and this contributes to the quiet, introspective mood of the painting.

LIGHT EFFECTS

Light plays an important part in this branch of painting. A room comes to life on a bright day, with sunlight making patterns on the floor, walls, or windowsills. In the evening, when lamps are on, the colors become richer and the atmosphere cozier. Sunlight effects are, of course, short-lived, so you may need to work in shifts at the same time each day. Artificial light will not change, but it may not give you sufficient illumination for your painting. Overcome this by putting a separate light source beside your easel. Or make sketches and color notes and construct the painting in the daytime.

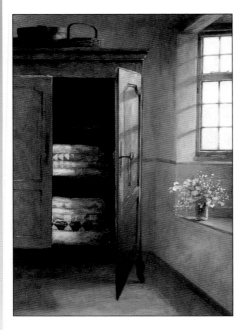

ORGANIZING THE SUBJECT

The artist made an exciting composition by slightly reorganizing his subject; opening the closet door and placing a vase of flowers on the window seat. The door and the left-hand side of the bedding in the closet catch the light from the window, so that the pattern of light and shade is continued into the center of the picture.

ARMOIRE WITH QUILTS by Ron Bone

The open door makes a center of interest of the bedding, and provides a light tone to balance the flowers and window.

By opening the door, a tall shape was created, with diagonals at top and bottom, which intersect the horizontals of floor and closet.

The delicate, sketchy treatment contributes to the light, airy impression.

The broken-color technique, with many different colors laid over one another, imparts a shimmering quality.

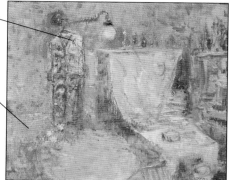

INTERIOR WITH EIGHTEENTH-CENTURY HARLEQUIN SUIT by John Rosser

LIGHT AND COLOR

This painting is also concerned with the effects of light, but the theme was addressed less specifically than in the painting opposite. Here, the quality of light is expressed through a high tonal key.

1 Make a drawing in pencil, checking that the vertical lines are straight. Then stick down the masking tape, rubbing it gently to ensure full adhesion.

2 You can now apply the paint as freely as you like, with no worry about keeping the edges clean.

3 When the paint is dry, peel off the tape to reveal a crisp edge.

PAINT HANDLING TIP

Paintings of interiors can be spoiled by wobbly lines. For example, it can be tricky to keep paint from spilling over an edge that should be crisp. You may find it helpful to use masking tape whenever you need to create a clean edge. You can use masking tape on paper or canvas, provided it is not too heavily textured, in which case the tape will only adhere to the raised grain, allowing paint to seep beneath.

Choosing Colors

The next, and most important, stage is choosing colors, then mixing and applying them. The following color exercises are very basic. To get the maximum benefit from them, thin opaque paint, rather than thick or transparent paint, is recommended. The latter kinds of paint will be explored later, and may be adapted to the exercises accordingly.

Choose a palette that will hold the paint well. Thin paint has a tendency to slop about. Try the kind with wells or use a small saucer or two.

Another point to note is that once acrylic paint is mixed, it will last indefinitely as long as the water in it doesn't evaporate. Any color that has been mixed and for any reason isn't needed right away, therefore, can be kept in a small jar or container as long as it is properly covered. For this purpose, I use discarded film cassette canisters, which are ideal for ready-

COLOR TEMPERATURE

Warm colors are those closer to the red end of the spectrum

Cold colors are those closer to the blue end of the spectrum

mixed paint, and are useful for taking outdoors for working. A dab of the color contained in them on the lid of the canister identifies them immediately.

Choosing colors is the very heart of painting and designing. The question is how to go about it?

What are the rules, or principles, if any, that apply?

The overwhelming compunction on seeing a color chart for the first time is to want them all—then give up because the choice is so wide. So it is refreshing to be told that the maximum number of colors needed to make up a palette that will do practically everything is five.

WHAT YOU WILL NEED

Some paint manufacturers sell starter sets, usually consisting of six to eight tubes of color. Some of these sets lack essential colors, while including colors you can easily mix yourself, so it may be preferable to make your own

selection. Alternatively, begin with an introductory set and add to it as you discover what you need.

A starter palette must contain two of each of the primary colors: red, yellow, and blue. As you can see from the color swatches below, there are different versions of each color, and you need these in order to make successful secondary colors: greens, oranges, and purples.

SUGGESTED PALETTE

This suggested palette contains 13 colors, plus white, black, and gray, which is more than adequate for most subjects. The range of mixtures you can achieve with these colors is vast. If you want to reduce the initial expenditure, omit the cerulean blue and cobalt green light.

Cadmium lemon Cadmium yellow deep Yellow ochre Cadmium red medium

Alizarin crimson Dioxazine purple Ultramarine blue Phthalo blue Cerulean blue

Cobalt green light Chromium oxide green Raw umber Burnt umber

Secondary colors are a mixture of two primaries, so you could manage with the six basic colors alone, plus white, but this would mean spending as much time mixing colors as painting. Also, some of the ready-made secondary colors, notably the purples, are brighter and purer than those you can mix, so a small selection of these is recommended.

A good range of browns, known as tertiary colors, can be mixed from primary and secondary colors, but again, it saves time to have one or two on hand. Tertiaries and secondaries are useful both on their own and for modifying other colors. For example, a little purple added to a sky blue will deepen it, and a touch of brown mixed into an over-bright green or red will reduce its intensity. The gray recommended in the starter palette was formulated especially for toning down colors without making them appear muddy.

Paint has a sheen while still wet.

It dries matte, and the color darkens.

DARKER DRYING

Acrylic becomes much darker as it dries on the paper. This is because of the medium used in the manufacture of the paper, which is invisible when dry but white when wet. Therefore, mixing colors just a little lighter than you need is necessary. If you want to match a color exactly, perhaps to correct an error, paint a swatch on a piece of paper, hold it up against the color to be matched, and adjust.

BASIC COLOR THEORY

Some knowledge of color theory is necessary to artists of all levels, and it would be difficult to know how to start painting if, for instance, you didn't know that red and yellow make orange, yellow and blue make green, and so on. Without wanting to discourage the pursuit of a subject that is both useful and fascinating, however, there is a limit to how much theory is actually relevant to the artist.

One of the main problems for the painter is that the theory of color is based on the pure colors of the spectrum—red, orange, yellow, green, blue, indigo, and violet. These seven pure colors, the colors of the rainbow, are the basis of all theoretical studies of color, for scientists and painters alike.

The artist's color wheel is a simplified version of the spectrum colors, minus the indigo. The wheel, which is used universally as a guide to color, is usually divided into six sections. These comprise the three basic colors—red, yellow, and blue—known as the "artists' primaries," which cannot be mixed from any other colors. Between the appropriate primary colors are the colors that are mixed from these—orange, green, and violet. These are the "secondary" colors.

Unfortunately for the painter,

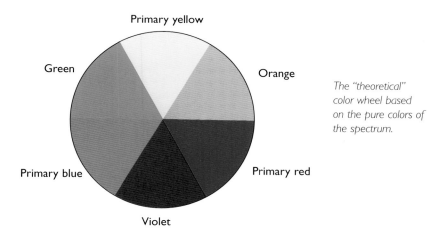

Primary yellow

Green

Orange

Primary blue

Primary red

Violet

The "theoretical" color wheel based on the pure colors of the spectrum.

however, artists' pigments do not mix in the same way that Newton's spectrum colors did. While it is true that primary red and yellow paints do mix to make orange, it is not accurate to say that primary blue and red make violet. In fact, they produce a rather dull brown.

It is important to know how to mix the color you want from the pigments on your palette and how this will affect your painting. In other words, there is only so much to be gained from charts and diagrams and a great deal to be learned from experience and practice.

Complementary Colors

Complementary colors are those that lie opposite one another in the color circle. As a follow-up to the last exercises, and for further variations on color combinations, here is the way in which complementaries work in contrast with one another. They make an interesting point about the way we respond to groupings of colors, and it is absolutely essential for designers to know what they consist of for future use.

Examples of primaries and secondaries consists of: yellow and violet, blue and orange, red and green. And in all these pairs,

primaries are always apparent— hence the necessity of mixing them together to make secondaries in the early stages. One gets to understand them better this way.

These colors are opposite yet require each other: They produce a vividness when adjacent, yet annihilate each other when mixed to produce a dark gray (useful as the basis for a neutral background, or underpainting to work on). Another useful peculiarity of contrasting complementaries is that, though opposite, they have the remarkable ability to appear perfectly

THE PRIMARY COLORS

This chart shows yellow, blue, and red with their contrasting complementaries, violet, orange, and green.

COMPLEMENTARY CONTRASTS

A complementary contrast chart incorporating intermediate tones and tints.

harmonious. This makes using them an agreeable pictorial device for enhancing both paintings and designs. By utilizing the complementary contrasts chart, you have the beginnings of ready-made color schemes that can be easily carried out with acrylic.

In the top row of squares move through yellow, orange, red, to violet, and the bottom row from violet, blue, green, and back to yellow. Begin with the primaries and secondaries directly over their opposite, and place the intermediate tones and tints in between in their correct order. The gradations of green should be placed under the appropriate gradations of violet above.

As an additional exercise, painting your own color circle, will give valuable experience in trying out colors straight from the tube without any mixing at all. Alternatively, the secondaries can be mixed from the primaries to observe how possible it is to do so successfully.

Whichever method is adopted, it will remain as another interesting alternative in exploring the possibilities of color.

Complementaries, and indeed, color generally, can be further studied with profit. Another simple experiment is to try painting on a color underpainting. Usually you begin on a white surface. Painting on a colored surface opens up a great number of possibilities, too many to start with perhaps.

Color Relationships

PICTURE MAKING PRINCIPLES

When you begin painting a picture you may find your colors behaving unexpectedly. You mix the apparently perfect color for something only to discover that it looks too bright or too dull, too dark or too pale when you put other colors next to it. This is because colors are relative, changing in appearance according to their context. A brown that seems almost black on a white surface will look much paler if surrounded by black. A blue may show a greenish bias if juxtaposed with a more purplish blue.

WARM AND COOL COLORS

You can also find that a color pushes itself forward in a way that you did not plan. This is usually because it is too warm. Artists classify colors in terms of temperature. Reds and yellows, and all mixtures containing these colors, are perceived as warm, while blues, blue-greens, and blue-grays are cool. The warm colors tend to advance to the front of the picture, and the cool ones to recede. One of the ways of creating the illusion of space in a landscape is to use warm colors in the foreground and cooler ones for the middle and far distance.

But like hue and tone, color temperature is relative. Blue, although on the cool side of the color wheel, can appear warm next to a cool neutral gray, so it is not just a question of painting the distant hills blue—you must relate the blue to the other colors. There are also temperature variations within the same color groups. Some blues are warmer than others. The same applies to reds, yellows, and greens. Even the so-called neutral colors have a warm or cool bias.

Alizarin crimson Cadmium red

Cadmium lemon Cadmium yellow

Cerulean blue Ultramarine blue

WARM AND COOL PRIMARY COLORS
The swatches above show two reds, two blues, and two yellows from the starter palette. In each case, one is warmer than the other. The crimson has a slight blue-purple bias and is cooler than the cadmium red. The lemon yellow is acid and greenish, cooler than the more orange cadmium yellow. Cerulean blue is cooler than the slightly purple ultramarine.

COLOR TEMPERATURE

The colors on the right-hand side, greens and blues shading into purple, are cooler than those on the left, where yellows shade into oranges, reds, and finally magenta, a red-purple.

Warm **Cool**

RELATIVE TONES

Neither colors nor tones can be judged in isolation. This brown looks darker on white than it does on black. In the third swatch, the brown is so close in tone to the surrounding gray that it is barely distinguishable; half-close your eyes and it disappears.

TEMPERATURE AND HUE

The first four squares show how the warm red and yellow stand forward from the cooler blue and blue-green in the center. But when the cool colors, which would normally be considered recessive, are seen against a neutral gray, as in the squares at far right, they advance. The most vivid color will always stand out even if it is technically "cool."

PAINT TEXTURE

The relative warmth or coolness of a color is not the only thing that makes it advance or recede. Thick paint has a stronger presence than thin, and will thrust itself forward regardless of the color. The Old Masters, notably Rembrandt, created powerful three-dimensional effects by using thin paint for the backgrounds of portraits, with thick impastos for the highlights on faces or details of clothing.

Primary and Secondary Colors

One of the most important skills is mixing paint colors to match those you see in the subject. To some extent this will come with practice. When you have been painting for a while you will begin to evaluate colors in terms of the pigment or mixture that most closely resembles them. Instead of seeing a sky as simply blue, you will view it more specifically—perhaps as a mixture of cerulean blue and ultramarine. The first stage in successful color mixing is to become familiar with your paints.

PRINTER'S COLOR WHEEL
This six-color wheel, made with printing inks, shows the three primary colors and three secondary colors, which are mixtures of the primary on either side of them. The wheel could be extended to 12 or even 24 colors showing a wider range of secondary color mixtures, but there would still be only three primaries.

PIGMENT WHEEL
This painted wheel, made with the selection of primary colors given for the starter palette, shows that they do not all correspond with the pure primary values of the printed wheel. The secondaries are mixtures of the primaries on either side, but of course, a much larger selection could be achieved by varying the primary components. Some possible mixtures are shown opposite.

THE COLOR WHEEL

Red, blue, and yellow are known as primary, because they cannot be produced from mixtures of other colors and are completely unlike one another. On the color wheel, which is the standard device for showing color relationships, they are placed at equal distances from one another. Between them lie the secondary colors— orange, green, and violet—which are made from mixtures of two primaries.

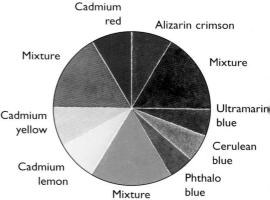

Cadmium red
Alizarin crimson
Mixture
Mixture
Cadmium yellow
Ultramarine blue
Cerulean blue
Cadmium lemon
Phthalo blue
Mixture

MIXING SECONDARY COLORS

The painted wheel opposite shows that the reds, yellows, and blues all have a slight bias toward one of the secondary colors. Ultramarine, for example, veers toward red, and phthalo blue toward green. The most vivid secondary colors are made by mixing the pair of primaries with a bias toward each other, while more muted hues are produced by pairing those with an opposite bias. In each of these charts—except the one for the green mixtures, which contains two pairs of "like" primaries—the top row shows two "like" primary colors with the secondary mixture, and below are mixtures of "unlike" primaries. The latter can provide some useful ideas for greens and browns, where you often want subtle rather than vivid colors. The range can be extended by varying the proportions of the colors.

Like primaries

Unlike primaries

Like primaries

Unlike primaries

Like primaries

Unlike primaries

MIXING ORANGES

The first mixture is the brightest, ideal for the pure colors of flowers, or for oranges in a still life. The second mixture would be suitable for subjects, such as autumn foliage, or mixed with a little more white for skin tones.

MIXING GREENS

The top mixture, of an acid yellow and a greenish blue, might be used in a portrait or still life featuring a fabric or ceramic of this color, but is too brash for the greens of nature. For more natural-looking greens, it would be better to use a combination of "unlike" primaries, one of which is shown in the second row.

MIXING PURPLES

A true purple can only be made from the red and blue shown in the top row, so for purple flowers these must be your starting point. But for the red-brown of some tree trunks, or mauvish-browns of shadows, mixtures of the "unlike" primaries may be more satisfactory.

DIFFICULT COLORS

Although you can mix most of the secondary colors you need from two primaries, some ready-made secondary colors are stronger and brighter than those you can mix. It is almost impossible to mix a purple to equal the intensity of the various tube purples, and the tube version of cadmium orange is more vivid than a yellow-red mixture. The starter palette includes one purple, but you may find in time that you need another, along with an orange, especially for floral subjects.

Neutral Colors

The range of unobtrusive browns, grays, and beiges classed as neutral are important in painting, because they set off the other colors and make them appear brighter by contrast. They can be more difficult to mix than secondaries for three reasons. First, they often involve mixing more than two colors; neutrals are also known as "tertiary," because they typically have three color components. Second, they are often hard to identify in terms of paint colors and sometimes even to name. The third reason is that they are affected by surrounding colors. A bluish or purplish gray that seems right on the palette may look too bright when placed next to an even more neutral color.

This is because none of these colors conforms to the dictionary definition of neutral, i.e., without bias. The only true neutrals would be black and white, which are not classed as colors, and gray that is a mixture of the two. In painting and in nature the so-called neutrals all have a color bias. Gray will rarely be a straight mix of black and white; it may have a blue, mauve or brown tinge. Browns may veer toward red, green, or blue and beiges toward pink or yellow.

EXAMPLE ONE *These are just four of the many possible mixtures made from three primaries. All colors look darker when the paint is used thickly, so for opaque methods, add white for a pale neutral.*

EXAMPLE TWO *Different versions of the three primary colors were used for these tertiary mixtures. Any of these primaries could be mixed with those shown above to increase the range of neutrals.*

MIXTURES

You can make neutrals by adding small quantities of color to black or brown, but this can give dull results. Neutrals with more character can be achieved by mixing the three primary colors—or one primary color and one secondary, which is in effect the same thing: a combination of three colors. Some of these mixtures are shown opposite, but there are many other possibilities. Artists develop their own recipes for making neutrals, so make a note of any successful mixtures.

THREE-COLOR MIXTURES *Because the primary colors are unlike one another, a mixture of all three in equal proportions produces a neutral. If you want a neutral with a more positive color bias, increase the quantity of one of the colors. To lighten the shade, add white, or water if you are using transparent paint.*

NEUTRALIZING WITH GRAY

Davy's gray is a color specially formulated for the purpose of toning down, or neutralizing colors. This is useful if you want to reduce intensity but do not want a true neutral. Davy's gray is one of the more transparent pigments, so if you are using opaque paint rather than the transparent color shown here, you may need to add a little white, also.

Cerulean blue

With Davy's gray added

Ultramarine blue

With Davy's gray added

Chromium oxide green

With Davy's gray added

A brownish neutral against orange

The same neutral against gray

A green-gray neutral against blue

The same neutral against gray

RELATIVE VALUE

These examples show how colors are affected by neighboring hues. The neutral colors look less neutral when seen against a gray made by mixing black and white than when juxtaposed with vivid colors. When you paint, apply some of the brighter colors before mixing the neutrals, so that you have something to judge them against.

MIXING COMPLEMENTARY COLORS

The colors that are opposite one another on the color wheel are known as complementary colors. There are three pairs of these: red and green, blue and orange, yellow and violet, each comprising one primary color and one secondary. Juxtaposing these colors in a painting creates vibrant, sometimes startling effects, but when mixed together they cancel each other out, and are therefore a quick way of mixing neutral browns and grays. By varying the proportion of complementary colors, an extensive range of tertiary mixtures can be produced.

Light and Dark

The word "tone" describes the lightness or darkness of a color, regardless of its hue. All pure colors have an intrinsic tone. Reds are much darker than yellows, and the blues and purples (with the exception of cerulean blue) are darker still. You will often need to lighten these darker colors. Applying undiluted ultramarine blue for a sky, for example, would not create a realistic effect.

When you use the paint opaquely, you can lighten colors by adding white. For transparent watercolor effects, water performs the same function; the more diluted the paint, the paler the color. But some colors cannot be lightened without changing their character. Red becomes pink when mixed with white, so to create highlights on a red object it is sometimes better to add yellow.

Using black to darken colors can also change them. It does not affect the nature of blues and purples, and works well for the neutral colors, such as browns and grays, but it can have unexpected effects, changing yellow into green, and red into brown.

MIXING COLORS

When you want to mix a very light color, such as pale pink or blue, always start with white, adding small amounts of color until the tone is right. The pure colors are much stronger than white, and if you work the other way around you may have to use a large quantity of white to counteract their effect.

Pick up a small amount of the darker color with the tip of the brush. Mix it in well, adding more paint if needed.

Cadmium lemon + white

Cadmium yellow deep + white

Yellow ochre + white

Cadmium red medium + white

Alizarin crimson + white

Dioxazine purple + white

Ultramarine blue + white

Phthalo blue + white

Cerulean blue + white

Cobalt green + white

Chromium oxide green + white

Raw umber + white

Burnt umber + white

MAKING COLORS LIGHTER

These swatches (above) show each of the starter palette colors mixed with varying amounts of white. As you will see, adding white to lighten colors has some interesting effects. Red loses its redness, and the intensity of yellows and greens is reduced. The same applies when you add water for transparent applications. But purple and ultramarine blue become more intense when a little white is added. This is because they are naturally dark-toned, looking almost black if thickly applied, and a slight lightening makes the colors emerge more clearly.

LIGHTENING WITH OTHER COLORS

If you do not want to use white, lift the tone by mixing in a related but lighter-toned color.

DARKENING WITH OTHER COLORS

For the colors that cannot be mixed with black, achieve deeper tones by mixing in a darker related color.

Add cerulean blue to ultramarine blue

Add dioxazine purple to alizarin crimson

Add lemon yellow to yellow ochre

Add yellow ochre to lemon yellow

Add yellow ochre to raw umber

Add burnt umber to cadmium red

Mixing Colors

Successful color mixing—that is, achieving colors that correspond to those you see—is mainly a matter of experience. However, there are some hints that will help you cut down on trial-and-error time.

PRIMARIES AND SECONDARIES

Red, yellow, and blue are known as the primary colors, which means they can't be made from mixtures of other colors. But each of these colors comes in two or more versions, with different color biases. If you want a bright secondary color (the term for a mixture of two primaries), always choose the two primaries that have a bias toward each other. For example, if you want a clear, vivid green, use lemon yellow, which is slightly blue, and phthalocyanine or Prussian blue, both of which are slightly green.

LIGHT AND DARK

If you are painting thin, in "watercolor mode," you make colors lighter by using more water. The thinner the paint is, the more the white paper will show through. For opaque treatments, colors are lightened by adding white. This must be done with caution, however, as white changes the character of some colors.

Black can be used to darken colors, but this can also alter their character. Red mixed with black becomes brown; yellow mixed with black becomes green.

READY-MADE SECONDARIES

You don't, of course, have to mix secondaries at all. Paint manufacturers make a good selection of secondary colors, many of which are stronger than the mixtures you can achieve on your palette. It is a common fallacy that all colors can be mixed from the three primaries. You can paint a reasonably satisfactory picture with only three colors—but you won't achieve much subtlety of color.

OPACITY AND TRANSPARENCY

One more factor to consider is the relative opacity of the colors you intend to mix. Some acrylic colors are transparent or translucent and others opaque. If you want a transparent mixture or are mixing colors by overlaying them on the picture surface (see glazing and transparent techniques), you must take care not to mix the two types or you will lose the transparency. Certain brands of acrylic, notably Liquitex, are marked either "opaque" or "transparent" on the tube, but with others you will have to find out through experience.

These swatches show a warm and cool version of each of the primary colors. Color names have not been given, as they vary from one range to another.

These secondary colors have been produced by mixing the two primaries that are biased toward one another. Muted versions of the same colors can be made by mixing opposite primaries, that is, one warm and one cool.

Here one of each of the primary colors (top) is shown mixed with white—first 25%, then 50%, and finally 75%. Notice that the red immediately becomes pink, while the other colors remain true to their characters.

Here the primary colors have been mixed with black—first 100%, then 75%, 50%, and finally 25%. Although the blue remains recognizable, the red changes to brown and the yellow to green.

Although red and blue do produce purples, such mixtures are seldom as bright and pure as the tube purples. A selection of ready-made purples and magentas is essential for subjects such as flowers, and they are also useful for modifying other colors.

Although it is easy enough to mix a range of greens from blue and yellow, or black and yellow, most artists have a few ready-made greens, which can be used on their own or to modify other colors.

2-COLOR MIXES

When colors are mixed, they become reduced in intensity, that is, less brilliant. A mixed secondary or tertiary color is seldom as bright as any of its components. That is why most art teachers recommend mixing no more than three colors. When beginning artists fail to achieve the color they want, they sometimes panic and mix four or five different colors, which usually results in muddy-looking colors.

Unless you are mixing neutral colors, it is wise to restrict yourself initially to two-color mixtures plus white. You will be surprised at how many hues, or gradations in color, you can achieve with the starter palette colors. A selection of possible mixtures is shown here, but you can extend the range considerably by varying the proportions of the colors and adding different amounts of white. If a color does not look right when you apply it, remember that you can alter it later with transparent glazes or washes of water-diluted paint.

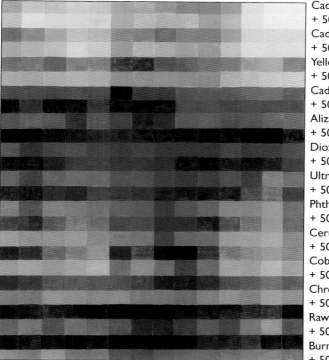

Cadmium lemon
+ 50% white
Cadmium yellow
+ 50% white
Yellow ochre
+ 50% white
Cadmium red medium
+ 50% white
Alizarin crimson
+ 50% white
Dioxazine purple
+ 50% white
Ultramarine blue
+ 50% white
Phthalo blue
+ 50% white
Cerulean blue
+ 50% white
Cobalt green light
+ 50% white
Chromium oxide green
+ 50% white
Raw umber
+ 50% white
Burnt umber
+ 50% white

Pimlott

Style

Although purely abstract paintings often appear unrelated to the real world, they nearly always have their starting point in something seen and experienced in the artist's life. The same applies to paintings that we would describe as fantasies, or works of the imagination. The human mind has a limited capacity for pure invention—reality appears even in dreams, although these may produce strange juxtapositions as well as distortions of time and space. Because dreams play tricks with reality, dream imagery can be an important source for imaginative painting.

Abstraction and Fantasy

The Surrealist painters, who drew heavily on contemporary theories of the subconscious, explored the incongruity and irrationality of buried images. In the words of André Breton, the purpose of Surrealism was "to resolve the previously contradictory conditions of dreams and reality into an absolute reality—a super-reality."

But Surrealism is not the only kind of imaginative painting, nor did the Surrealists invent the idea of working from dreams and the imagination. The great poet and painter William Blake (1757–1827) and the equally great Spanish artist Francisco de Goya (1746–1828) both produced works in which imagination and reality are fused. It is no accident that these two artists were almost exact contemporaries—at this time there was a reaction against the increasing tendency to explain everything in terms of scientific fact, reducing the significance of what had been thought magical and mysterious.

BLIND GUITARIST by Francisco de Goya (1778), Museo del Prado, Madrid

ABSTRACT SHAPES

Abstraction has a different starting point. Here it is the arrangement of shapes and colors that forms the visual message. The word "abstract" tends to alarm people, because it seems to imply that a painting will be impossible to understand. But paintings are not made to be read like books—they must be appreciated on their own terms. Most good paintings have an abstract quality, and you will often hear the phrase "abstract shapes" applied to a landscape, a portrait, or a still life. This simply means that the relationship of shapes in the painting has its own importance, regardless of what the shapes may represent. Sometimes if you turn a painting upside down, making it unfamiliar, you will see this abstract pattern emerge. Pure abstraction is outside the scope of this book, but on the following pages you will see some examples of how the visual world can provide a stimulus for semi-abstract treatments.

Arranging Shapes

Still life and interiors can both form useful starting points for exploring abstract shapes and relationships. You could arrange a still-life group as you like and choose a viewpoint that makes a strong pattern of shapes. For example, looking down from a high viewpoint—you could arrange the group on the floor—reduces the objects' familiarity and lets a pattern of shapes emerge. You can see this effect in Paul Bartlett's painting. Another approach is to silhouette objects against a strong light by placing them on a windowsill, for example, so that they form a pattern of dark shapes against light.

EVENING STILL LIFE by Robert Tilling
A still life of objects silhouetted against the light could be a good starting point for a semi-abstract treatment, as backlighting cuts out much of the detail and allows you to see shape rather than form. Here the composition is seen entirely as an arrangement of shapes and colors, with thick impastos achieved by thickening the paint with sand contrasting with areas of flat color.

SIZEWELL SERIES by David Ferry
In this painting, one of a series based on a nuclear power station, the artist has made a semi-abstract composite from various objects seen while working on the site. The dark, curving shape at top left, for example, was derived from a technical drawing of part of a reactor. Acrylic, used on thick paper, has been combined with collage; the bottom of the picture is a collaged photocopy of a photograph, stuck on with PVA medium (glue) and glazed over. PVA diluted with water has also been used as a glazing medium. Ferry prefers this to ordinary acrylic medium, as it imparts gloss and transparency to the colors.

In interiors, especially sparse and uncluttered ones such as empty rooms or corridors, the intersecting vertical and horizontal shapes will often suggest an abstract treatment. Roy Sparkes's painting is not an abstract, but it relies on abstract qualities for its impact.

Texture can be important in abstract and semi-abstract treatments. When you depart from the strict representation of objects, you often need to compensate by providing surface interest. By manipulating color, shape, and texture, you can stress the existence of the painting as an object in its own right.

STILL LIFE by Paul Powis
Although most of the objects here are clearly recognizable, the painting can be read as an arrangement of abstract shapes. This painting is on paper with a precolored ground, and the artist has combined a brightly colored chalk line drawing with acrylic applied wet with large brushes—notice how it has been allowed to dribble down the paper.

MUSIC HOUSE, LIVERPOOL by Roy Sparkes
This painting, on textured mountboard, is one of a series inspired by a visit to a wharf then being converted into Liverpool's Music House. The artist was attracted to the subject largely because of the abstract quality of the unfinished and unfurnished building, and the painting emphasizes the interaction of geometric shapes.

Visual Stimuli

Abstraction (as opposed to pure abstract painting, where there are no recognizable references to actuality) involves choosing those elements of the visual world that create an effect, regardless of whether they are descriptive in the usual sense of the word. More or less anything—with the possible exception of the human figure—can provide the stimulus for semi-abstract paintings. You will often see powerful abstract shapes in a landscape, for example, or in the human-made environment—buildings are a common subject for such treatments. The reason for excluding the human figure is that it is very difficult to dissociate ourselves from fellow humans as a set of shapes. It can and has been done, but it is not the best subject area to begin with.

Abstracting can in any case be quite difficult, particularly if you are painting directly from a subject. It is usually more satisfactory to work from sketches, or to use a painting you have already done as the basis for an abstraction or series of abstractions. Many artists work in this way, pushing an idea further and further to distill what they see as the essence of the subject.

ABSTRACTION OF BOATS
by Mike Bernard
Textures feature strongly in this painting also, but here the artist has used collage—a technique that encourages a nonrepresentational approach—together with inks, pastels, and acrylic. He has explored the theme of boats in a number of his paintings, and in this work has pushed the subject further toward the realm of the abstract.

SUMMER HARBOUR by Robert Tilling
In the painting below, the artist has used a variety of impasto textures for this dramatic semi-abstraction in which the landscape and building are reduced to their bare bones.

143

Imagination

Letting your imagination dictate how and what you paint can be very satisfying, but it can't be done to order. Indeed many people find it impossible. Children use their imaginations naturally, perhaps because their minds are less cluttered with seen images and direct experience than those of adults. Certainly the ability is often lost as they grow older.

There can be many sources for imaginative painting, dreams being one. Music and literature, especially poetry, can provide initial inspiration, and so can

TREE DRAGON by Ray Mutimer
The idea of turning a natural feature such as a tree or rock into a mythical or imaginary animal has a long history, and such fantasies are often seen in children's books, science-fiction illustrations, and animated films. The artist has treated the subject very cleverly, with the naturalistic representation of the surrounding woods enhancing the menace of the dragon forcing its way toward us.

THE INTRUDER by Roy Sparkes
This painting also gives a sense of unease, though more subtly than in Ray Mutimer's painting. The two figures in the foreground have turned to look out of the painting at the intruder, unseen by us, but in fact the viewer of the painting—ourselves. Their expressions suggest that although they are aware of being watched, they do not know by whom. The strange colors and ambiguous shapes, particularly the amorphous forms between the figures, add to the dreamlike quality of the image.

FLUORESCENT ZEBRAS by Cheryl Osborne
A mixture of media has been used for this highly individual painting in which the artist has given free rein to her love of brilliant colors and decoration. Each of the zebra's stripes is painted in a different fluorescent acrylic color; the sky is oil pastel, acrylic, colored pencil, and inks, while the grass is a mixture of pearlized inks, gouache paint, and oil pastel.

memory, which—like dreams—often plays tricks with reality. It can be interesting to try to recreate a scene, perhaps a landscape or townscape, from memory, as you will often find you have overlaid your impressions of shape, color, and so on, with more personal and subjective feelings, which will emerge in the painting.

Objects can form the starting point of an imaginative treatment, also. A strangely shaped tree, for example, might suggest a monster, as in Ray Mutimer's painting, while a favorite ornament or object with particular associations could spark off a fantasy with a visual storyline.

If you find it difficult to let your mind roam free, a change of media may help. Collage, for example, invites a nonliberal treatment, and you could find that removing the restrictions of accurate representation enables you to develop a painting in a different way.

145

Poetry is a productive source of inspiration for Rosalind Cuthbert, and so is memory. She sometimes bases her compositions on a poetic idea combined with sketches, photographs and real objects to produce highly personal interpretations, often using mixed-media techniques. The next three pages show you how the artist created this painting.

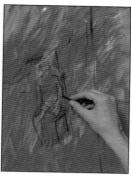

2 This allover brilliant red ground would be an unusual choice for a purely naturalistic painting, but in this case it helps the artist to create her own visual world. The figure, which is not intended to play a dominant role, is drawn very lightly in charcoal.

1 The visual reference material is spread out on a drawing board, and compositional ideas are worked out in a sketchbook. The photographs of figures were too specific, so the artist has rejected them in favor of a more stylized treatment.

3 To enhance the illusory quality of the image, the paint is applied in light veils of color, scumbled over the red. The brush-work is deliberately nondescriptive.

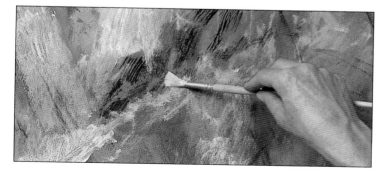

4 The artist continues to build up color effects in the background of the painting, now beginning subtly to define the large tree and the band of light running across the picture.

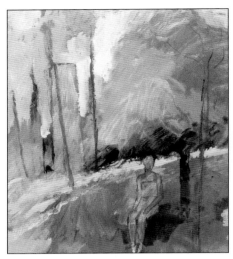

6 Charcoal is used to sketch in the bird with the drawing kept light because it w be overlaid with paint at a later stage.

5 The framework of the composition is established, with the trees, tower, and figure loosely suggested. The red ground shows through the overlaid colors, creating a luminous effect.

7 The form of the left-hand bird has now been built up with white paint over the charcoal, and attention is given to the tree, which is the dominant shape in the composition.

8 The foreground is as yet undefin Here two feathers are to be place painted realistically in contrast to th more amorphous treatment of the figure. An actual pheasant's feather placed on the picture to enable th artist to recreate its shape. The same procedure is followed for th white feather.

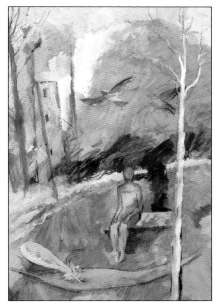

9 At this stage the painting is assessed to see how much work remains to be done and which areas need to be strengthened and defined.

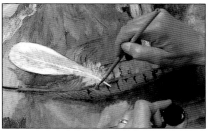

10 The foreground is given attention first. Details are added to the pheasant feather with black ink and a sharpened reed pen.

11 The birds, which provide a balance for the feathers by association, have been painted red, and blues are now introduced into the foliage of the tree.

12 The artist continues to strengthen the tones and colors of the tree with a heavier application of charcoal than previously. Powerful contrasts of tone are required in this area, as the tree is the focal point of the compostion.

13 Finally, white paint is used to "cut in" over the edges of the tree, giving a clearer outline as well as increasing the tonal contrast.

Effects Achieved by Acrylics

BACKGROUND

Today's decorative painting is a versatile art and its repertoire includes a range of background effects. Although plain backgrounds are still popular, they can be replaced with an assortment of exciting choices to complement your decoration.

You can imitate material such as marble or wood grain—a faux (or false) effect—or create a design from your own imagination. Structural paints make embossing an easy task. Stamp products are available for introducing pretty repeat patterns. Pen brushes, fitted with a cartridge, are a revolutionary new product if you want to short-circuit the sometimes tedious repetition of loading your brush, especially when working with one color over a relatively large area.

The major manufacturers cater specifically to the decorative painter's need for a good range of colors for either plain or special-effect backgrounds. These paints are available in conveniently sized pots with an opening suitable for a large brush. Gone are the days of mixing background colors from several tubes with the wastage that occurred because you did not use it all.

The background effects illustrated here are only a few of the possibilities; they will give you some ideas for your own experiments.

STIPPLING

A stippled effect is applied over a background color. Ideally, you will use a stippling brush, which has stiff bristles shaved flat. An alternative is an old brush whose hairs shoot out in all directions like a wild weed. Chop the hairs off flat with a razor knife.

2 Touch the end of the brush hairs to the paint, taking care not to pick up too much paint. Tap the brush up and down over a practice sheet of paper to release a scatter of speckles. They should appear even and clean. If there is too much paint in the brush, the hairs stick together, producing a globby rather than a crisp effect. Once the specks are satisfactory, begin on your piece. Tap in strips, being careful not to bend the bristles, which would create smudges.

1 Choose your colors: a light background with darker stipples, or a dark background with lighter stipples. Apply three coats of background color.

SPONGING

A sponged effect can be produced by two methods, or both combined, as in this example—sponging off and sponging on.

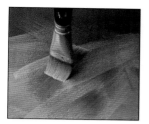

1 Choose contrasting colors, for example, yellow and green. Paint on three coats of background. Once dry, apply your chosen, contrasting color, mixed with a little retarder to delay the drying time.

2 Dampen a sea sponge, squeezing out the excess water, and use it to blot off the paint just applied. Twist your wrist as you work to achieve a more random effect. This is sponging off.

3 Dry this with a hairdryer. Now we add the sponged-on effect. Use a brush to transfer some more of the color just used onto your sponge. Lightly touch some of this paint onto the sponged-off surface in random applications.

RANDOM RAG DROPS

This is a subtle effect created on a washed background.

1 Apply one or two coats of color wash. Use a water spray to keep the surface damp.

2 Drop a cotton dishcloth randomly onto the surface to create faint, washed-out effects here and there.

3 Once you are happy with the mottled background, allow to dry. Remember not to be too fussy and continue—the effect should be random and subtle.

Subjects

Practical considerations play a crucial part when it comes to deciding what to paint. The medium is flexible enough to accommodate almost any subject you want to paint. The outdoor world offers an infinite number of enticing landscape scenes for the artist, from dramatic mountainscapes, seascapes, and wide panoramas to intimate corners of a park or yard. It is not suprising that landscape is the most popular of all painting subjects. Unlike landscapes and architectural subjects, still life and portraiture subjects can be organized in advance of painting and are, therefore, an excellent means of building up technical and compositional skills.

Still Life

The removal of objects or groups of objects from the normal scenery of life is the essence of what has become known as still life. It is almost as if a cameralike process has been in operation throughout the history of still life painting, picking out the detail of the world and bringing it into focus, which makes us aware of its visual properties.

One tradition of still life painting has been to capture elements from everyday life, taking such domestic items as a piece of bread on a plate, an unfinished meal, or a pair of shoes left on the floor. These are fragments that fascinate the viewer because they freeze a small component of that routine that is so often ignored but, in fact, makes up the stuff of people's lives.

Still life has yet another attraction for artists—it can be something that is totally controlled, an artificial arrangement of those objects that interest the painter. Thus it can not only capture fragments of a scene but also extract objects from their immediate environment and place them in situations that bring out their own characteristics and individuality.

MIST ON THE MOUNTAINS by William Roberts

STRUCTURED SIMPLICITY

This group comprises the simplest of ingredients, but instead of aiming for the natural look that most still life painters seek, the artist introduced a sense of artificiality through his arrangement. The effect is enhanced by his smooth, yet hard-edged technique, and the controlled use of color and tone. As is often the case in still life paintings, the spaces between objects—known as negative shapes—play an important part, with the small dark areas between and beside the two bowls balancing the shapes of the pears.

Giorgio Morandi (1890–1964) is a good example of a still life painter who went to great lengths to choose subjects that fitted into his scheme of things. He concentrated on simple shapes placed in uncomplicated surroundings and painted everything in the same muted tones—earth colors and whites. He controlled things to such an extent that he would find a shape he liked—usually a bowl or bottle—and then give it a coat of white paint, forcing it into his own visual arrangement.

THE STILL LIFE GROUP

The term "still life" defines any inanimate object or group of objects, including organic forms such as fruits, vegetables, or cut flowers. The choice of subject matter is therefore vast: You can paint anything from one apple on a plate to elaborate arrangements containing many elements, colors, and textures. Your early selections will probably depend upon what you have around the house, but if you find you enjoy this branch of painting, it is a good idea to be aware of paintable objects and build up a collection.

NATURAL FORMS

This painting has a more natural look than the still life opposite, partly because it features objects you would expect to see outdoors on a seashore. But, in fact, it was arranged with equal care to achieve a balance of colors, tones, and shapes, and an interesting composition. Notice how the dark tones of the metal waste in the center are echoed by those of the branch of heather at the top and the narrow dark shape on the right. The color scheme is based on the blue-yellow contrast, with the yellow of the foreground stone repeated on the shell and driftwood..

DRIFTWOOD WITH HEATHER by Jill Mirza

ADDITIONAL COLORS

Still life is a varied subject—you may be painting anything from fruit and vegetables to a pile of newspapers on a table—so it is not possible to provide a list of additional colors that would be suitable for all eventualities. However, the first four colors shown here will help you with the vivid hues of fruit, and the others are useful for richer or more subtle color mixtures.

Cadmium orange	Bismouth yellow	Perylene red	Gold ochre	Payne's gray	Mars violet deep

Arranging a Still Life

In still life you do a lot of the composition before you begin to paint, so it is wise to take your time choosing and arranging the objects. Paul Cézanne, who painted some of the finest still lifes ever seen, sometimes spent days setting up his groups, which usually consisted of home-grown fruits and vegetables and humble objects from his studio. You need not go to his lengths, but make sure that the group provides an interesting and well-balanced composition before proceeding.

The objects must look as though they belong together naturally, so avoid unlikely contrasts of category. Partnering fruits with a pair of shoes, for example, would create an unsettling effect.

VARYING THE FORMAT

The objects are linked by their setting and by the way some of them overlap.

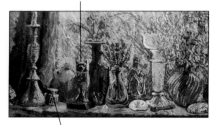

Placing the small pot at an angle helps to direct the eyes inward toward the tall blue vase in the center.

WINDOWSILL by Gerald Cains
The nature of this subject, with many objects lined together on a long windowsill, called for a horizontal format, but if the artist had used the traditional landscape format proportions, he could not have included all of the objects. He therefore extended the rectangle to make a long, narrow shape that echoes that of the windowsill to back up the theme of the painting.

SETTING UP THE GROUP

When you have collected your objects, place them on your chosen surface, and move them around until the group begins to jell. Let some items overlap, because this makes a pictorial link between them, but take care that you can see both objects clearly. Do not crowd all the elements together.

In all paintings, you want to lead the viewer's eyes into and around the picture, so try to set up signposting devices. The folds in a piece of drapery hanging over the table front will guide the gaze to the objects. A small pitcher at the front of the picture could be placed so that the spout points toward objects farther back.

Finally, check the arrangement through a viewfinder. This will frame the subject and give you an idea of how it will look as a painting. It will also help you to choose the format: A vertical rectangle might work better as a horizontal shape or a square.

TRYING OUT ARRANGEMENTS

Do not overcrowd your group; simple arrangements often work best. Be prepared to discard some of your initial choices, or to replace them if the shapes and colors do not harmonize.

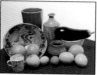

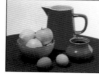

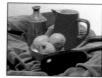

This group is overcrowded and fussy, and the objects do not fit together comfortably.

The removal of many items and the introduction of the red pitcher makes a more pleasing arrangement with a good color balance.

The folds of the cloth provide a sense of movement, and the color sets off those of the objects.

This arrangement is agreeably simple, with the curve of the table balancing the circles and ovals of bowls and eggs.

The contrast between the dark rich blue and the vivid yellow makes this the focal point, drawing the eye into the picture.

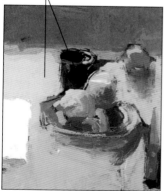

NEGATIVE SHAPES

The spaces between and behind objects are known as negative shapes. The objects themselves are the positive ones.

PLANNING AND SPONTANEITY

The bold, free brushwork and the simplicity of the subject give an immediate impression of spontaneity. But the arrangement and composition were meticulously planned to provide a perfect balance of tones, color, and shapes. There is also a strong feeling of space. The artist was dealing with a larger area of space than that in the windowsill picture opposite, and ensured that our eyes are led from the front to the back of the painting by the overlapping shapes and the inward-pointing knife.

The fruits were arranged so that the negative shapes balance the positive ones. The reversed image to the right shows the effective interplay of the shapes.

FRUIT AND VEGETABLES

Fruit and vegetables are the ideal subjects for a first still life. They are relatively inexpensive, readily available, and provide a wide choice of colors, shapes, and textures. Another advantage is that they need not be wasted—you can eat them when you have finished the painting. The composition will usually be more interesting if you include some non-organic objects, such as crockery, for contrast. Avoid too many colors; the painting may look incoherent unless there is a definite color theme. Here the artist made a bold choice by using primary colors—red, blue, and yellow. Another possibility would be complementary colors—for example, a combination of red and green vegetables, or yellow fruit against a mauve background.

The gentle curve of the leek tops is exaggerated to improve the composition of the painting. Some detail is suppressed.

The heavy red of the background drapery is lightened in the painting to prevent it from becoming over-dominant.

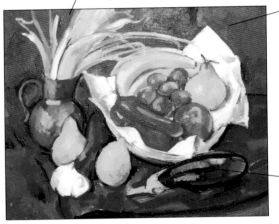

The blackish purple of the eggplant is conveyed in a wider variety of colors in the painting, and the overall tone is lifted for a delicate effect.

STILL LIFE IN PRIMARY COLORS by Ted Gauld

Paintings of arranged objects can look dull and static, unless you create a sense of movement in the composition. The eye must travel around the painting rather than focusing first on one thing and then another. There is a strong sense of rhythm here, with the curve of the leek top, which echoes that of the banana, guiding the eye around from the left to the right of the picture. It then travels down, via the edge of the drapery, to the eggplant and upward again to the lemons and pitcher. The painting is on primed canvas. The artist works in both oils and acrylics, applying similar methods to both media, but for acrylic he uses synthetic brushes instead of oil painter's bristle ones.

1 To plan the composition and relationships of the objects, a light, sketchy charcoal drawing was made first. The excess charcoal was then flicked off with a rag so that it would not mix with the paint and muddy it. The charcoal drawing was reinforced by a brush drawing in heavily thinned blue paint, before establishing areas of color—beginning with the blue pitcher, and yellow fruit and eggplant stalk.

2 The transparent underpainting is complete. The advantage of working this way is that it allows you to establish the color scheme and composition of the painting at an early stage.

3 The colors are reinforced with thicker, opaque paint. Repeating the same or similar colors in different areas of the painting ensures compositional unity. Here the blue of the pitcher is used again for the drapery.

4 As the applications of thicker color progress, areas of light and shade begin to be defined.

5 The artist continues the process of building up with juicy opaque paint, laying on patches of color all over the picture surface. Varying the brush strokes helps to impart a lively feeling to the painting.

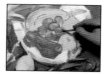

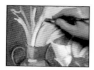

6 After applying opaque paint to the background, and taking it around the edges of the leeks, a touch of detail is added to define the individual leaves. The side of a square-ended brush is used to make a broad line of yellow.

7 Highlights are usually left until last in opaque methods, because it is easier to judge how light they need to be when all of the other colors are in place. Here, a near-white highlight is modified with a touch of pale pink.

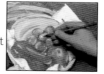

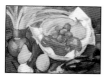

8 The dark shape of the eggplant could have been too dominant in the immediate foreground. Blues and reds were brought in before adding this gray-blue highlight to create a color relationship with the background and with the drapery.

Gouache in Still Life

Gouache is a water-based paint but thicker and more opaque than watercolor. The colors are clear and bright; mixed with white they create sparkling pastel tints. Use thick paint straight from the tube to overlay strong colors, or thin it with water to flood in light washes.

At first glance, this painting may appear to be carefully detailed and realistic, but as the steps show, the technique is fluid and informal. The first step, for example, is not a meticulous drawing but a mass of vivid, liquid pools of color, suggesting basic forms. As the paint is laid on in layers of loose streaks and patches, the impression of solidity and texture gradually emerges. Each object is described by carefully studying the subject colors and translating these into the painting.

In general, the technique used for this painting was to thicken the paint slightly with each application; but thin washes are laid in the final stage to indicate textures and shadows. The combination of thin washes with flat, opaque patches of color is most effective in capturing the reflective surface of the bottle and glass.

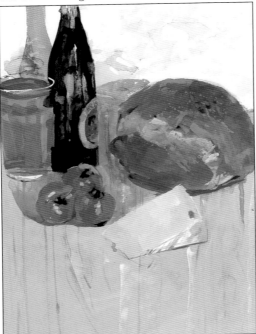

1 With a No. 8 sable brush, lay in the basic shapes of the objects with thin, wet paint. Use burnt umber, sap green, magenta, and yellow and let the colors flow together.

 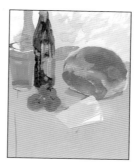 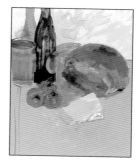

2 With a No. 5 brush, put in yellow ochre around the shapes and into the foreground. Work over the bottle and loaf of bread, painting in shadow details.

3 Indicate shadows in the background with a thin layer of green. Apply small patches of solid color to show form and surface texture in each object.

4 With a No. 12 brush, block in small dabs and streaks of color, developing the tones and textures.

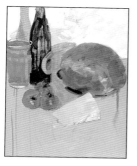 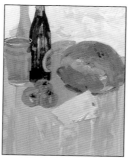

A. After dampening the paper with water in the shape of the object, the artist lays in a wash of color, allowing it to bleed over the damp area.

5 Intensify the contrast of light and dark with white highlights and brown shadows with the No. 5 brush. Work into the background with white.

6 Work over the foreground and background with light tones of pink and yellow, keeping the paint thin. Spatter brown and black over the loaf.

B. Over the dry underpainting, the artist here blocks in the label on the bottle with dryish paint.

C. Using paint directly from the tube and a large brush well loaded with water, the background is blocked in.

Shape and Color

Many still lifes have a theme running through them. Sometimes artists paint objects that have personal significance, such as favorite books or souvenirs of an exotic vacation, to express an aspect of themselves. But the theme can be a purely pictorial one of color or shape. These two paintings have a theme based on two main color contrasts: yellow and blue in one, and red and blue in the other. Both have a shape theme also, but a dissimilar one. The composition of the fruit still life (right) is based on a repetition of similar shapes—circles and ovals—while in the teapot and box painting (below), the artist explores the interplay of different shapes.

OVERLAYING COLOR

A simple grouping like this, featuring mundane objects with little intrinsic beauty, could look dull, but this painting certainly does not. The contrast of shapes catches the eye, and so do the wonderfully rich color effects. The small areas of green provide a near-complementary contrast that enriches the reds, but what makes each individual area of color so vibrant is the way the paint is used. One color is allowed to show through another to build up a scintillating glow. You can see this effect especially clearly on the tall box. The artist worked on paper, using both medium-consistency paint and thin, transparent washes and glazes.

A number of different colors show through on another to give a luminous glow.

Brush strokes of thin, semi-transparent pink are scumbled over thicker applications of red and blue. The patches of still-visible blue make a color link with the pitcher.

Thinned paint was allowed to dribble down the paper, contributing to the free, spontaneous feeling of the composition.

STILL LIFE WITH BLUE COFFEE POT by Paul Powis

This group of leaves, the same tones as the dark patches in the background blue, forms a visual bridge, uniting the two areas of the picture.

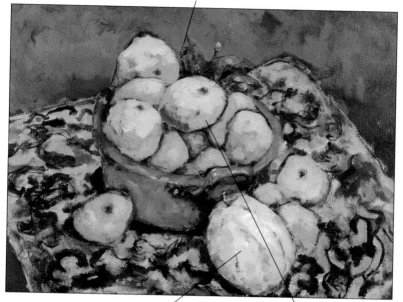

TANGERINES by W. Joe Innes

Brush strokes of thick impasto help to bring the melon forward in the picture space. Touches of blue in the shadows link it with the bowl.

The forms of the fruit are built up with broad strokes of a square-ended brush. A variety of different yellows, oranges, and yellow-greens are used, but kept close in tone, so that they read as one color.

COLOR AND COMPOSITION

Much of the impact of this painting stems from the contrasts of color and tone, with the deep, rich blue making the yellows call out. The color scheme is deliberately restricted, with similar blues used for both the bowl and the background, and the neutral colors of the cloth providing the perfect foil for the lime green of the melon. The painting conveys a feeling of strength and solidity, partly because the forms are so convincingly modeled, but also because of the well-balanced geometric structure of the composition. The group of fruit forms a rhomboid shape sloping to the left, counterpointed by the roughly rectangular shape of the patterned cloth sloping in the opposite direction. The painting is on canvas, and the artist uses the paint thickly throughout.

Flowers

One of the great advantages of painting flowers is that you need never be at a loss for a subject. Whether or not you grow your own flowers, freshly cut blooms and foliage can be obtained even in winter. Or you could paint dried flowers. These can make colorful groups, and will remain unchanged, unlike fresh flowers, which begin to decay even before you have the chance to put them into a vase.

Cut flowers may last for a week, but you cannot take a leisurely approach to your painting, because your arrangement will alter in the course of a day. Even if blooms and leaves do not wither, other changes will occur. Buds that were tightly curled when you put them into the vase will gradually unfurl.

For this reason it is wise to begin with a simple group, or to simplify by the way you paint. Flowers are complex in shape and an elaborate arrangement of different species could take a long time to complete if each bloom is painted in detail. You can treat flowers broadly and still give the impression of a particular type as long as you get the shapes, colors and proportions right—and your painting will have more life than if you labor over every petal and stamen. Once you have chosen and set up your subject, analyze it in terms of shape and color. Look first for the shape made by the group as a whole, and then at the individual shapes of the flowers and leaves. It can concentrate the mind to make one or two quick pencil sketches before you paint. This will also help you to select what is most important. You may find that you can create a more exciting painting if you omit some of the smaller flower heads, and perhaps treat leaves as a broad area of tone and color rather than portraying each one.

SELECTIVE DETAIL

The four central blooms are treated more precisely than those behind, where white brush strokes were painted over the background blue in order to merge with it. The shapes of the flowers and petals are accurately observed, but the artist was less concerned with strict realism than with creating a sense of atmosphere; this is achieved by linking the flowers with the moon and night sky.

STARGAZER LILIES by Ros Cuthbert

COMPOSING A FLORAL GROUP

In a still life or landscape there are usually several components to arrange into a composition, but a floral group contains only one key element—the flowers in their container. The simplicity of the subject often distracts attention from composition. Because the flowers are what you are painting, it seems natural to place the group in the middle of the picture. But as we have seen, a painting will nearly always be more interesting if you avoid symmetry. When you have arranged the group, look at it through a viewfinder. If you want the vase in or near the center, break the symmetry by letting the flowers themselves form an irregular shape—perhaps taller at one side. If the arrangement does not seem to fit comfortably within the rectangle of the picture, there may be too much space around it, so do not forget the option of cropping at the top or sides.

BACKGROUNDS

It is important to remember that backgrounds are not just blank areas; they are part of the picture and require as much attention as any other. In flower paintings, the background is often left vague, as a suggestion of space to provide a context for the flowers, but even so, the tones and colors must play their part in the overall effect. Sometimes the background can exert a more positive role. You might, for example, put your arrangement on a windowsill, with the window frame providing a geometric framework to set off the freer forms of the flowers. You could make pattern the main theme of the picture.

The broad brush strokes of thinned white follow the top curve of the flower group, and the verticals echo the upright of the vase.

WHITE DAISIES by Anne-Marie Butlin

A LIVELY FEELING

Bear in mind that flowers are living organisms, and try to find ways of preventing them from looking too static. This artist conveyed a feeling of vitality through the composition of the group and through her handling of the paint. The curves in the foreground form the perfect counterpoint to the upright shape of the vase and echo the curve of the petals on the right. Loose, sweeping brush strokes follow the curves and are repeated on the generalized background.

FLOWER STUDY by Debra Manifold

COMPOSING WITH SHAPES

The arrangement of shapes and the interplay of dark and light tones is the visual theme of this painting, and the artist avoided adding detail that could have weakened the impact. The groups of flowers are treated as broad areas of dark but subtly varied color, and the brilliant red of the poppies sings out against the dark tones on one side and the grays of the background on the other.

The composition is based on the dark wedge shape that cuts diagonally across the picture.

POPPIES by Mike Bernard

The wide horizontal format chosen for this collage-and-mixed-media flower group has allowed the artist to make the most of the flowers and stems, while reducing the vase to little more than a suggestion of a shape. The background is always an important element in still life compositions, and here it has been fully integrated into the painting, with the shapes, colors, and textures echoing those of the flowers.

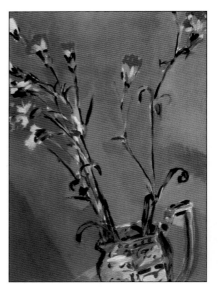

MY MOTHER'S JUG by Gerry Baptist

Clever use has been made of the cropping device in this painting on canvas board, and the sense of movement is enhanced by the deliberate tilting of the jug and the broad brush strokes in the background, which follow the direction of the stems.

Shape and Structure

You do not need to be a botanist to paint flowers, but understanding their basic structure will avoid frustration and help you depict them successfully.

You would not draw a figure without considering the muscles and bones that form it and the way the feet and legs support the body's weight. The same applies to a plant. Why does it have stems and leaves, and what supports the petals?

The purpose of the leaves is to photosynthesize and produce carbohydrates, which are used by the rest of the plant, while roots gather water and nutrients and send them back up the stem. The stem must be strong enough to support the flower. It is unlikely to be thinner at the bottom or it could not support the weight above, and if it suddenly took a step sideways when it disappears behind another stem, the flower would have real problems, defying gravity being one of them. If a long leaf seems to bend over, as they often do, it must still have a logical progression with no broken lines for the veins.

ANATOMY OF A PLANT
Familiarity with the structure of a plant, and knowing how the parts join up and at what angle the flowers grow from the stem, all give a painting credibility.

FLOWER SHAPES
Many flower heads can be simplified into a basic circle, and when a circle is seen in perspective, turned away from you, it becomes an ellipse. Practice drawing ellipses, as they are the magic formula for solving a number of problems that beset the beginner. Hold a saucer up and look at it full face; imagine it is a daisy and turn it slowly on its axis so that it is flat. Just for fun, as it is a very loose analogy, lightly draw the saucer on three or four different planes and

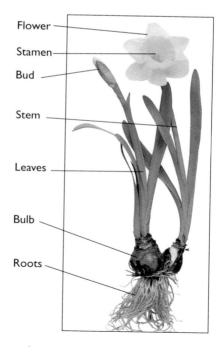

Flower
Stamen
Bud
Stem
Leaves
Bulb
Roots

then put it down and turn its shape into a flower—a simple daisy.

Think about what happens when the basic shape is broken. For example, if your saucer of a daisy had a limp petal hanging down on one side and you pushed it back into place, it would fit back into the ellipse; it would not have become longer or thinner, though it might look that way. Perspective and foreshortening need to be observed carefully, and the various angles can be worked out in a separate drawing with guide lines made obvious.

More complex flowers, where the basic shape is not obvious, require more acute observation, but the principles are the same. If you do not understand how or why a shape is as it is, take one flower apart very gently and slowly and see how it is put together. Look at the different stages and see whether an older flower has the start of a seed pod developing. This sounds obvious, but for a spray on a single stem you will need to show the progression from the wide open flowers at the bottom to the bud at the top.

BELL-SHAPED

Bell-shaped flowers follow the three-dimensional shape of a bell; the stem supports the flower from the center top, and the petals fall around the axis of the stamen, which corresponds to a bell's clapper. The shadow is deep on the inside, and there may be a curve of light to the back inner edge.

Front view Three-quarter view

Front view Back view

TRUMPET-SHAPED

A lily, with its stamens protruding out like symbols of noise, makes an obvious trumpet. Many other tubular flowers start with a cone shape; then the petals flare into the familiar trumpet shape. Make sure that the petals curve into a center point, even when they disappear into shade.

168

Flowers in their Natural Habitat

The outside world provides a rich and varied source of subjects for the flower painter. Those who have gardens are fortunate, because they can combine horticultural and artistic interests. What could be more rewarding than immortalizing a particularly successful flowerbed, or a shrub that you have nurtured from infancy? But non-gardeners need not feel deprived, because equally exciting subjects can be found in public parks and gardens.

If you venture into the countryside, you will have a chance to paint wild flowers. These look best in their natural habitat, and do not take readily to being cut and placed in vases. In fact, picking wild flowers is often actively discouraged or outlawed in the interests of environmental protection.

PICTORIAL CHOICES

Outdoor flower studies are landscapes in miniature, involving a similar decision-making process. Will you place the flowers in the foreground or in the middle distance? Will you focus on a group of flowers, or even one or two blooms, and treat them in detail, or take a broader approach?

To some extent the subject will dictate the answers. Large, dramatic, or vividly colored flowers, such as sunflowers, roses, or lilies, could benefit from a close-up viewpoint, while small densely growing flowers, such as bluebells or primroses carpeting a wood, could be placed in the middle distance and treated as a broad mass of color. A yard filled with contrasting colors might be dealt with in the same way, with one or two of the nearer flower heads and leaves picked out in detail.

FLOWERS IN CLOSE-UP

Some flowers make their impact en masse, while other dramatic types demand a more closely focused approach. The artist merely suggested the outdoor setting in order to give the tall sunflowers, with their large flower heads and well-shaped leaves, pride of place in his painting. He chose to paint them from behind, emphasizing their habit of turning their heads toward the sun.

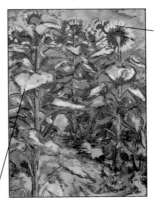

Each petal was painted with one stroke, the brush flicked outward at the end to taper the shape.

SUNFLOWERS FROM BEHIND
by David Cuthbert

Some of the leaves were outlined with linear brush strokes of dark red, but here a black-ink pen was used to emphasize the crisp edges.

PAINT HANDLING TIP

If all of the flowers in your painting are the same kind—for example, poppies or daisies in a field—those in the background will be recognizable simply as blobs of color, provided you treat the foreground flowers in greater detail. To do this, establish the main shapes and colors first, using thin or medium-consistency paint, then add detail in thicker paint when the picture is nearing completion.

1 Paint all of the poppies by applying separate brush marks of red, then put green around them. Do not make the flowers all the same shape, and make them smaller in the background.

2 Begin to define the foreground flowers, using thicker paint and introducing variations of tone and color suggesting individual petals. Finally, fill in the centers with a darker color using a pointed brush.

GIVING VISUAL CLUES

To depict a particular type of flower without going into detail, your first consideration must be color, which will give viewers a powerful clue. But color is not enough on its own; you must also convey an impression of how the flowers grow. There is no detail in this painting, but the solid mass of brilliant blue is immediately recognizable to anyone familiar with carpets of bluebells.

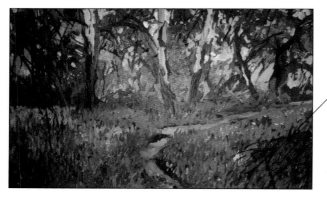

Each flower is painted with one brush stroke, upright or slightly slanting. The pink-brown of the path and the dark gray-greens in the background intensify the blues.

BLUEBELL WOODS, WINTERBOURNE by Daniel Stedman

Gouache

Working with a small sable brush and pale green, the artist works directly over the sketch, blocking in tones.

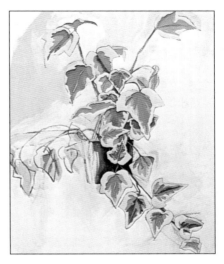

After the dark green of the leaves has dried, an opaque pale green is blocked in around these shapes.

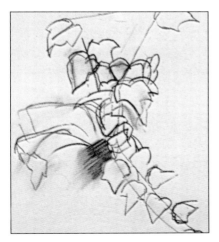

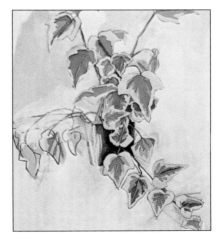

1 Draw the outline with charcoal, showing the shapes of the leaves and the stalks. Work freely, correcting where necessary by rubbing lightly over the lines.

2 Brush away excess charcoal dust from the surface of the drawing. With a No. 6 brush, work into the leaves to show the green patterning.

171

3 Fill in the whole shape of each leaf. Draw the stalks of the plant in red using the tip of the brush.

4 Revise the drawing with charcoal and paint over alterations with white. Continue to develop the colors, putting in a darker tone behind the leaves.

5 Build up the image piece by piece with applied color, gradually adding to the detail and refining the shapes.

6 Adjust the tones of the colors to draw out the natural contrasts. Complete each shape before moving onto the next.

SNOWY FLOWER: ACRYLIC

1 Using acrylic gives you a chance to introduce texture as well as a variety of color effects. It is also ideal for fine linear brush drawing. Start with a pencil drawing and then lay an overall wash of transparent acrylic (thinned with water, with no white).

2 For the petals, cut a piece of cardboard or plastic (old credit cards are ideal) to a suitable shape, mix up some thick white, and pull it across the shapes from the center outward. For the background, use a square-ended brush to make separate marks. This is the first stage of producing a broken-color effect to make the area more interesting.

3 Continue to build up the flower with both board and brushwork, then introduce more colors into the background before defining the stem and buds with dark green and a fine brush. If you prefer, you could use pen and colored ink for fine-line details, but avoid making hard lines around each petal.

IVY LEAF: ACRYLIC

1 Painting on smooth board or paper with thinned acrylic and sable or soft synthetic brushes gives you excellent control. You can include as much detail as you wish, and build up dark tones and rich colors through a series of glazes, as in watercolor. Begin with a wash of thin color over the whole leaf, avoiding making it too flat and even.

2 Lay further layers of thinned color, and for the final layer, use separate brush marks that do not fully cover the color beneath; this gives a realistic, slightly mottled impression. Finally, use a pale yellowy brown and a very small brush to draw in the veins. Because acrylic is opaque, you can work light over dark, whereas with watercolor, the veins would have to be reserved as highlights, a tedious and difficult process.

TREE SHAPES

Trees can be easily recognized by their general outline, size, color, and the density of their canopy. Even at a distance you will only need to give a few clues in your painting to make your trees recognizable as a particular species. Even though only part of this tree is visible, it is immediately recognizable by its silver trunk and by the way the small, sparse, leaves hang off the branches and catch the light. Note how the artist focuses on the lower branch, thereby keeping the eye in the center of the painting.

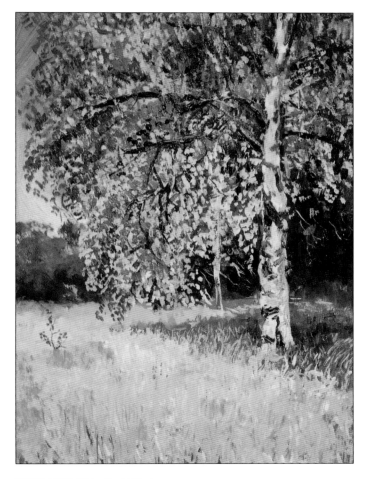

SILVER BIRCHES by Daniel Stedman

Weather

Landscape and weather conditions are inseparable. The extent to which the sky—and hence the weather—dictates the appearance of the landscape can be observed on any squally day, when rain replaces sun to alter the whole color scheme and tonal balance of the scene. In many cases, weather can even be the primary subject of the painting, as it is in Peter Burman's *River Deben, Suffolk*, where the composition relies on the patterns and light/dark masses made by the clouds and gleams of sunshine.

Effects like these are wonderful to paint, but also difficult because they are so transitory. You can sometimes recreate them from photographs, but it is wise to get into the habit of making small on-the-spot sketches as well. Even a pencil sketch with some written color notes can be more valuable than photographs, which are often unreliable in terms of color.

The changing seasons, too, affect the look of the landscape, even when the weather is technically the same—that is, sunny or overcast.

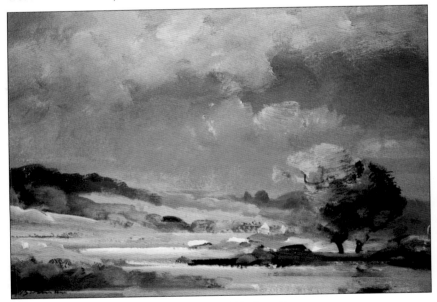

RIVER DEBEN, SUFFOLK by Peter Burman

In this painting on board, the artist has used thick, juicy paint and an oil paint technique, capturing the effects of light with bold, sure brush strokes. In the sky area and at the top of the tree, light paint has been scumbled over dark, with directional brush marks that create a strong sense of movement.

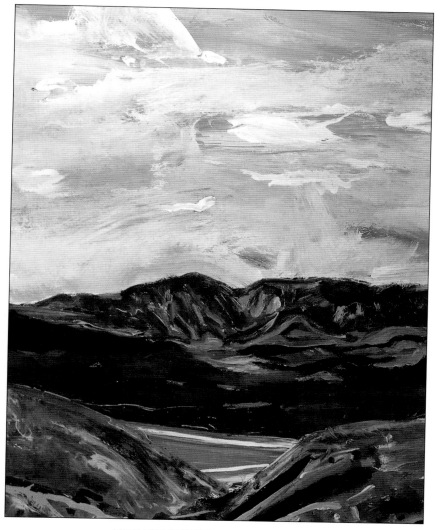

VIEW OF THE STEENS by William E. Shumway

In this painting on paper, the artist has stressed the changeable quality of light by exploiting one of the newer inventions in acrylic painting: interference colors. These are made with tiny particles of mica, which reflect the light in different ways according to the angle of viewing.

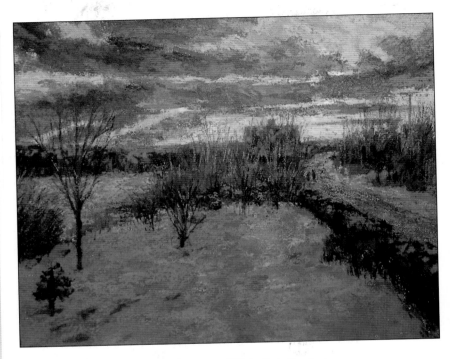

DAY'S END IN WINTER by Simie Maryles

Evening light and snow on the ground have presented the artist with a rich array of colors, from brilliant yellows, oranges, and turquoises to deep blues and purples. Acrylic plays a secondary role in this painting. Done on illustration board, it was used to make a brightly colored underpainting, on top of which pastel was thickly applied.

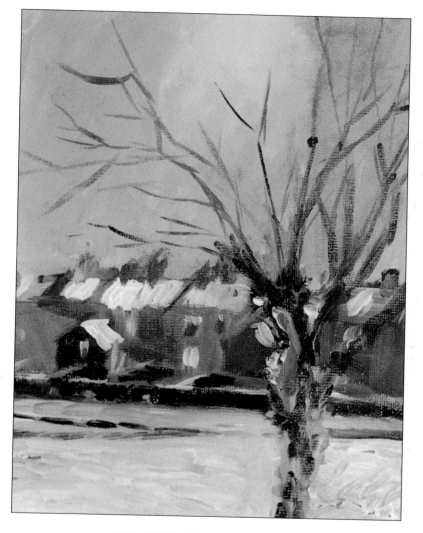

WELL STREET COMMON by Jane Strother

The subtle color effects of winter weather conditions are beautifully conveyed in this painting, with its carefully orchestrated gray-greens, blue-greens, and touches of warm brown. The artist has worked on textured paper, allowing its grain to break up the light brush strokes used for the tree to create delicate dry brush effects.

Wintry Landscape

A problem occurs with snowscapes that at first seems almost ludicrous in its simplicity—how to paint white snow on a white background.

The artist's way around this in the picture shown here was to cover the bottom half of the support, the area where most of the snow is found, with a coat of dark tint, black and burnt sienna. Over the sky area he put a lighter coat of yellow ochre mixed with a little black. He quite deliberately chose a warm tone to go underneath the snow, to achieve a contrast with the coldness of the subject, avoiding that rather amateur feeling of overall grayness and chill that plagues so many snow scenes. Warm earthy tints show through the snow in this picture, making it true to nature, in which warmth exists beneath the winter covering, and giving more substance to the image as a painting.

Normally, when painting on a white ground, you have to draw the composition in a darker color. So here—once the dark tints were laid down as a foundation—the artist drew the outlines in white. This produced a strange and attractive effect, rather like a photographic negative.

A thickening substance—gel medium in this case—was used so that the artist could build up a thick impastoed texture with a painting knife. He used this stiff mixture to block in the sky and the main areas. When painting snow, it is a popular error simply to paint it in as pure white. Here the artist worked from dark to light, first laying down the darker, muted colors—these would eventually represent indents and shadows—before painting in the white highlights of the snow. The actual amount of pure white was surprisingly small for a snow scene. Yet the effect is truly naturalistic and convincing.

USING GEL MEDIUM

Here the artist is using a knife to mix gel medium with the paint. In this case, the thickening agent is mixed with the color before being applied to the support. Occasionally gel is used on its own to create brush marks or other textures on the support and the color is then painted over this. The gel dries transparently, so although it lightens the color initially, the paint dries to its normal color.

1 When the artist made these sketches, the weather was too cold to encourage painting on the spot. Instead, he captured the scene in a sketchbook, and did the painting in the comfort of a studio.

2 Warm, dark undertones provide a contrasting base ready to receive the cold, light tones of the snow and sky. Because acrylic allows the artist to lay light colors over dark in a positive way, the white snow can now be applied directly to the darkened support.

3 The sky is blocked in with phalocyanine blue and white, laid thickly and flatly with a painting knife. Before moving directly onto the bright whiteness of the snow highlights, the artist first lays the duller, muted colors of the tracks and shadows in the road with ochres and grays.

4 Gel medium is mixed with the sky color to increase the rough, impastoed surface. Small areas of the ochre underpainting are left showing through the patches; these unify the painting by picking up similar tones elsewhere in the picture, as seen in the final painting (below left).

In the painting above, the artist tackles the problem of rendering an impression of falling snow so that it looks natural and uncontrived. One of the best ways of doing this is with the technique of spattering; the tiny droplets of paint fall onto the paper in a random fashion, which perfectly captures the effect of swirling snowflakes.

Skies

The sky is the light source for the land and, therefore, plays a central role in landscape painting. Even a composition that shows little or no sky will suggest the weather conditions and time of day, because sky and land are inter-dependent. A late evening sky produces completely different landscape colors from those seen under an intense midafternoon light. Bright sunshine gives strong light-dark contrasts, but under a clouded sky there are no cast shadows to provide these; therefore, everything looks flatter.

UNIFYING THE COMPOSITION

The sky is also important in compositional terms. The shapes of clouds can balance or echo shapes in the landscape, such as clumps of trees. This will link the separate areas of the picture. The colors of clouds can serve a similar function. Repeating colors from one part of the picture to another helps to unify the composition. You will often see blue-grays, browns, and yellows in clouds, and you can bring touches of these colors into the landscape features.

To avoid the clouds looking too heavy, slightly thinned white paint was laid over the blue.

The foliage is built up with blue, yellow-green, and very dark green.

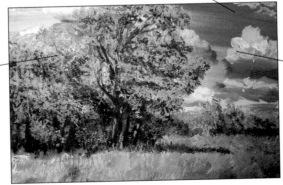

The clouds are simplified into areas of light, middle, and dark tone, with swirling brush marks giving a feeling of movement.

LYNDON WOODS by Daniel Stedman

ECHOING SHAPES

The trees form the focal point of this painting, while the sky is important to both the color scheme and the composition. The deep, rich blue sets off the gray-greens of the trees and foreground grass, and the shapes of the clouds echo those of the clumps of foliage to create a link between the two areas of the painting. There are also subtle color echoes, with touches of blue and mauve-gray appearing on the tree trunk and among the foliage greens.

CLOUD COLORS

When you are working from life, the main problem with clouds is that they move fast, so it is useful to know a few basic rules. A high sun gives a harsh, white light, and at this time you will see clouds with pure white tops, gray undersides, and little variation of color. A low evening sun casts a yellowish light, producing vivid yellows in the middle and blues or violets below, where the clouds are in shadow. If the sun is below the clouds, disappearing beneath the horizon, the bottoms will be illuminated and the tops will be in shadow.

CLOUD AND SUNLIGHT

One of the most exciting effects of all is that of intermittent sunlight, with clouds casting shadows on the land below, or the sun suddenly emerging from a bank of clouds to spotlight some landscape feature. Here a beam of sunlight created a natural focal point, illuminating the house and far end of the field.

NORFOLK LANDSCAPE
by Alan Oliver

The patch of blue and the creamy white sides of the clouds, lit by the emerging sun, form a center of interest in the sky area.

The lines and curves that radiate out from the patch of bright sunlight draw the eye in from the foreground to the buildings.

SKY PERSPECTIVE

We tend to think of the sky as a backdrop to the landscape, a vertical plane like the background wall in a still life. But it is not vertical; it resembles a huge bowl inverted over the landscape, and it is subject to the laws of linear and aerial perspective. As illustrated in the photograph below, the clouds directly above your head—in the center of the bowl—appear much larger than they do above the horizon, which is the rim of the bowl and the most distant point. As clouds recede, they appear progressively smaller, more closely bunched, and

with reduced tone and color contrasts. Even in a clear sky there is a change of tone and color toward the horizon; deep blue gently fades to a paler, greener hue.

The perspective effect of diminishing size is most obvious when the clouds are all of the same type and formation. These cumulus clouds show it clearly.

183

SUNSETS

When painting sunsets and sunrises, the most common mistake is to pile on too many pinks, oranges, and reds; this only results in the clichéd image often found on cheap postcards. The secret of success is to use your hot colors sparingly. Interwoven with the cool blues, grays, and violets in the rest of the sky, and offset by a shadowy landscape, the warm hues will take on a subtle, translucent glow.

Exercise restraint with your brush work, and be selective with your colors. It is tempting to put in every little streak of color—and more—but the result is fussy and amateurish. It is far better to understate the patterns in the sky, thereby creating an air of mystery and calm.

SUNSETS • MIXED MEDIA

A cloudy sky at sunset is particularly striking. Because the sun is lower than the clouds, the undersides of the clouds are brilliantly lit while their tops are thrown into shadow. For the same reason, the brightest clouds are low in the sky, becoming darker farther away from the sun. This sky study, worked in the style of Joseph Turner, the popular British landscape artist, has been painted in watercolor and gouache—the former for its

transparency and the latter for its brilliance of color.

First, the background sky colors were brushed in loosely, wet-in-wet, with watercolor. Then small strokes and dabs of opaque gouache were touched in for the clouds and allowed to diffuse softly into the still-damp colors beneath. The appearance of bright, luminous color is achieved by layering warm yellows, oranges, and pinks with cool blues and grays which, by contrast, accentuate the warm colors.

The Illusion of Space

There are two main ways of creating the impression of space and depth in landscape. One is by careful observation of the effects of linear perspective, which makes things appear smaller the farther away they are, and the other is by control of color and tone in the painting.

When you are working from photographs, which have already reduced the real world to two dimensions, it is relatively easy to see how large a foreground tree is in relation to one in the middle distance. But it is harder to assess relative sizes when you are out in the field. You may know the actual size of a lake or hill because you have walked around or up it, but if it is in the middle or far distance, it will appear tiny compared to some foreground feature such as a shrub or clump of flowers.

COLOR AND TONE

As objects recede in space, they become not only smaller but also less distinct, with narrower contrasts of tone and paler colors. This effect, caused by dust and moisture in the atmosphere, is called aerial or atmospheric perspective. The colors also become bluer or cooler. Create the illusion of space and depth by using progressively cooler colors for the middle and far distance, reserving the warm colors and strong tonal contrasts for the foreground.

Low horizon

A low horizon gives an open, airy feeling to a landscape and is especially suitable when there are dramatic cloud formations.

High horizon

PLACING THE HORIZON

The placing of the horizon also has a bearing on creating space. For example, you can often give a better impression of a panoramic landscape or an expanse of sea stretching away as far as you can see if you place the horizon low, letting the sky occupy about two-thirds of the picture space. For a hilly or mountainous landscape,

Here the horizon is high, but there is a convincing feeling of space, with the diagonal lines of the foreground field propelling us into the picture and toward the distant hills.

on the other hand, you could cut the sky down to a small sliver at the top, but emphasize space by arranging lead-in lines that draw the eye in from foreground to background.

185

Water

Perhaps because of its unique qualities of being both a transparent substance and a mirror, water has always fascinated artists—lakes, rivers, and seas are among the most popular of all landscape subjects. A still lake, gleaming pale blue or silver-white in the reflected light from the sky, even if it is only glimpsed in the distance, can provide a center of interest for a landscape painting (see Focal Points, pages 104–105), while reflections, or the patterns made by moving water, can form the main subject.

Still water presents no special problems to the artist, but waves or ripples can be tricky, as the patterns they make change from second to second, and you will need to observe such effects very carefully. You will find that there is a logic to the movements and that they repeat themselves, with waves curling and breaking in the same way and the ripples in a stream flowing around a rock in the same direction.

REFLECTED OBJECTS

Still water presents a perfect mirror image of what is above. This is an attractive feature, but it can cause problems. Unless you introduce some visual clues to explain the water surface, the reflections will make no sense—they will simply look like an upside-down version of the landscape. You can blur the reflections slightly in places, or introduce small ripples or some floating leaves.

Disturbed water plays tricks with reflections, scattering them so that they are no longer the same height and width as the objects. Tone and color vary more, too, because each ripple consists of two roughly diagonal planes, one of which may reflect the sky and the other some landscape feature.

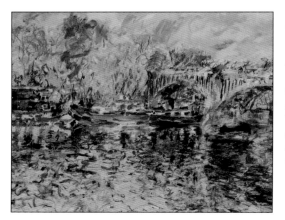

ALONG THE THAMES FROM UNDER RICHMOND BRIDGE I
by Jacquie Turner
Lively, active marks are used throughout the painting, integrating the water and reflections with the boats and trees.

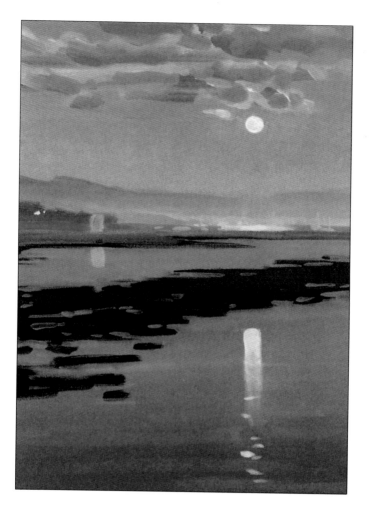

BLUE MOON by Marcia Burtt

Part of the impact of this painting stems from the omission of unnecessary detail. Broad horizontal brush marks of darker blue suggest ripples that pull the moon's reflection downward, but the contrasts of tone were kept to a minimum in order to give prominence to the reflection.

Water in Motion

Seascape is an enticing subject, but water is not always easy to paint, especially if you are working from a photograph. The advantage of the camera is that it can capture transient effects of light, but it freezes movement, making waves and ripples appear solid and static. If you copy this effect slavishly, your painting will fail to convey the essence of the subject. So use a photograph only as a starting point, as the artist has done here. By the use of lively brushwork, heightened colors, and increased tonal contrasts, an exciting and vibrant picture was produced.

Although small, this rock is an important feature in the composition, anchoring and stabilizing the overall movement.

The straight, dark band of cloud, which echoes the tones and colors of the foreground, provides balance in the painting.

A comparison of the finished painting (below) with the photograph (left) shows what can be done with a potentially dull subject. The artist used a layering technique, with one color showing through another to create a scintillating surface. In the sky, versions of each of the three primary colors (blue, pink-red, yellow) were laid one over another. The paint was thinned with water in the early stages, and used more thickly as the work progressed. The working surface is heavy watercolor paper.

The reflection of light on the water's surface contrasts with the dull colors of the sea to provide a sense of movement that was emphasized in the painting.

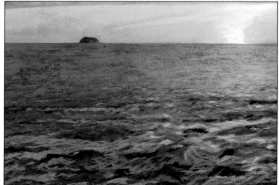

SEASCAPE by David Cuthbert

1 The blue undercolor of the sky and deep purple red of the sea were laid on with lightly watered paint. The artist darkens the color on the horizon with a mixture of raw umber and ultramarine. A light magenta is painted over the blue in the central area of the sky, allowing the blue to show through slightly.

2 The hump of rock and the dark band of cloud at the top of the sky are both left as blue. At the top of the sky, yellow is painted over the blue. The two colors mix optically, creating a greenish hue.

3 A blue similar to the first sky color is brought in for the sea. The broken-color effect, where the dark color shows through the scumbled blue, gives an excellent impression of light and movement.

4 Moving from one area to another so that all areas are at the same stage of completion, the stronger colors of the foreground sea are built up with decisive brush strokes of blue over orange. Next, the final sky color—yellow—is painted over the mauve created by the pink-blue mixture.

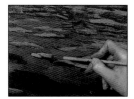

5 The greenish-yellow cloud band is left as it is, because a darker color is to be used for this. The band of cloud is deepened and enriched with a strong orange applied over the yellow-green. Again, you can see how one color shows through another to create a subtle mixture.

6 The effect of moving water is perfectly conveyed through varied brush marks, with one color laid over another. Toward the back of the sea, yellow was scumbled over blue to create a green glow. Touches of rich deep mauve are introduced over the earlier blues. The yellow-orange brush marks were made with the hairs of the brush slightly splayed in order to create a series of small, fine lines.

SIGMAS RACING by Jacquie Turner

The choppy water and the movement of the boats are conveyed through inventive and varied brushwork, finger-smudging, and scraping. The artist likes to work on smooth paper so that she can move the paint around, and she combines standard acrylic with liquid acrylic inks, watercolor, and touches of collage. The effect of the sprays of water and the highlights on the wavelets has been achieved by sticking on small pieces of prepainted tissue paper.

IPSWICH DOCKS by Gary Jeffrey

This lovely painting shows urban landscape at its most appealing—a true marriage of man-made and natural features. The artist has worked on canvas, and his painting technique is similar to an oil painter's, with the paint built up from thin to thick and some use of wet-into-wet techniques, particularly in the reflections.

CALM WATER

The smooth surface of a lake or river on a calm day is best depicted with broad, flat washes applied wet-into-wet. Use a minimum of brush strokes; otherwise, the illusion of the glassy surface will be lost.

CALM WATER • ACRYLIC

1 The three areas of the picture are simply blocked in with base colors. The band of water in the foreground is painted in phthalocyanine blue and white.

2 Touches of phthalocyanine blue and cobalt blue are added to the water's surface to convey the reflection of the sky in the water.

A RIVER SCENE

This leafy river scene is one that is very familiar to the artist who painted it, since it lies directly beneath the window of his studio. It provides an endless source of inspiration to the artist, as the colors change with the passing of the seasons.

The success of this picture lies in its simplicity, which captures the tranquil calm of a summer's day. Acrylic paint can be diluted with water or medium to the consistency of watercolor, allowing delicate, translucent effects to be obtained. For this painting, the artist chose to work as he would with watercolor. Without any preparatory drawing or underpainting, he applied his colors directly onto a sheet of stretched paper. Working from light to dark, in the traditional watercolor manner, the artist applied the colors in thin, transparent glazes that allow light to reflect off the white of the paper and up through the colors, giving them a luminous quality.

Because the washes are so transparent, mistakes cannot be covered up, so it is important to get things right the first time—especially since acrylic dries so quickly. The best way to work is boldly and decisively—as the artist did in this painting.

1 A photograph of the view from the artist's window. Compare this to the finished painting, and notice how the artist has simplified much of the detail to arrive at the essence of the scene.

2 Without any preliminary underdrawing, the artist begins by blocking in the main areas of the composition with pale tints of Payne's gray and raw umber.

3 While the first tones are still damp, washes of Hooker's green mixed with a little raw umber in the shaded areas are worked into the trees and the foreground.

4 The quiet ripples on the water's surface are indicated with pale lines of Payne's gray and raw umber.

5 The artist uses sable brushes throughout the painting process to achieve the softness of form and delicacy of detail necessary.

6 The artist strengthens the tones in the painting by applying glazes of color, one on top of the other. The glazes are very thin and transparent, allowing the underlayer to glow up through the overlayer and create the luminous effect of a watercolor painting.

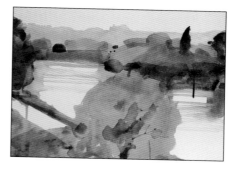

7 Opaque white is used to redefine complicated edges, such as the leaves on the trees. The paint is not used thickly but is still watery in texture.

8 The completed painting has all the freshness and sparkle of a watercolor. The artist has resisted the temptation to overwork the washes or to build up the paint or opaque layers. In addition, he has cut out much of the detail in the scene and presented us with his own personal interpretation of a much-loved subject.

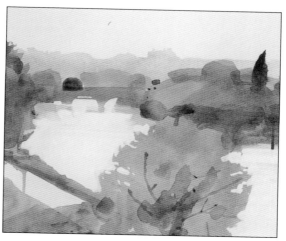

Buildings and Townscapes

All the subject areas in painting overlap to some extent, and townscapes are really only another kind of landscape painting. However, while landscape might be said to consist of mainly natural features, in a town you are surrounded by a man-made environment. This doesn't, of course, mean that there are no natural features—many cities are well endowed with rivers and trees, and it can be this very contrast between nature's work and that of humankind that makes townscapes such an exciting subject.

VIEWPOINT

There are some problems associated with painting in urban environments, however, one being that it isn't always easy to find a suitable place to work. If there is a handy seat, the chances are it won't give you the viewpoint you want, and it can be nerve-wracking to stand at an easel in the middle of a busy sidewalk, trying to ignore the comments of passersby. You will become accustomed to these as you gain confidence, but for initial attempts you might try finding a vantage point at the window of a public building, or in a café.

POWELL STREET by Benjamin Eisenstat

An attractive painting subject can sometimes be marred by the presence of cars and people, but they are an integral part of a daytime cityscape. Including vehicles, pedestrians, and other city features can also help the composition.

PERSPECTIVE AND PROPORTION

The idea of having to cope with the intricacies of perspective puts many people off urban subjects, but it is not really so difficult provided you remember the basic rule that all receding parallel lines appear to meet at a point on the horizon. The important word here is horizon, which is an imaginary line located at your own eye level. If you are painting from a high viewpoint, such as a tower or hilltop, the lines will slope upward, while if the viewpoint is low, they will slope downward. The only real problem is that because perspective is dependent on viewpoint, it changes as soon as you move, even from a sitting to a standing position, so when you make the preliminary drawing for the painting, keep as still as you can.

Although a building won't look convincing if the perspective is wrong, an even more important factor in conveying its character is proportion: how tall it is in relation to its width; how many windows there are and how much space between them; and so on.

PLACE AND ATMOSPHERE

All towns and cities have their own particular feeling, so if you are painting townscapes rather than portraits of individual buildings, try to analyze what this feeling is and find ways of creating a sense of place by giving visual clues. In an exotic location, for example, people's clothing and characteristic postures will be strong indicators, while in a busy modern city you can make cars and typical street "furniture" part of the composition.

It is often possible to convey a sense of place through color or texture alone, making a play of light, bright colors or strong tonal contrasts in a sunny Mediterranean town, and exploiting low-key colors, such as grays and browns, in a northern industrial setting.

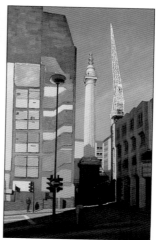

THE NEW CITY by Richard French
One of the most exciting visual phenomena in modern cities is that of reflections in the many large expanses of glass, often distorted in intriguing ways. Here the artist has mimicked the effect of such reflections by using multiple layers of acrylic glazes.

THE MONUMENT by Brian Yale
In this painting of London's Monument and the surrounding buildings, the approach is almost photographic, with minute attention paid to every detail and texture. The composition is beautifully worked out, with the diagonal line formed by the edge of the dark shadow leading the eye up the right-hand building and the crane that forms a balance for the Monument itself.

SPRING ON THE EMBANKMENT by Gary Jeffrey
Cityscapes are often avoided by amateur painters, but the pictures on this page demonstrate that they can be a rewarding and stimulating subject. For this painting on canvas board, the artist has chosen a high viewpoint, which has allowed him to treat the cars as a vivid area of color and pattern contrasting with the solid white slabs of the buildings behind.

BROAD STREET, OXFORD
by Neil Watson

This painting is full of atmosphere and movement, the latter quality accentuated by the strong brushwork and the motion of the cyclist in the foreground. The surface is canvas board, and the paint has been used thinly— notice that it has been allowed to dribble down the board in the sky area. The artist began with washes of acrylic mixed with gloss medium, after which he fleshed out the painting and developed some linear detail using inks, which were sealed in with more gloss medium.

RESTAURANTS, KEW ROAD
by Gary Jeffrey

The signpost, the just-legible names of the shops, the figure, and the horse-chestnut trees all combine to give a feeling of place; this scene would be immediately recognized by most Londoners. The time chosen, early evening with the lights just coming on, has provided a wonderfully rich color scheme, with the brilliant reds and yellows standing out against the buildings and pavement blued by the fading light. The painting is on drawing paper primed with shellac.

BACKS OF BUILDINGS, ST MARY'S ROAD, SOUTHAMPTON (ENGLAND)
by Mike Bernard

Collage is a technique particularly well suited to architectural subjects, and here it has been skillfully used, in conjunction with acrylic, inks, and pastel. The varieties of paper used for collaging give an impression of textures without attempting to imitate reality. The printed paper in the right-hand area of the foreground has been placed upside down to prevent it from being overly obtrusive.

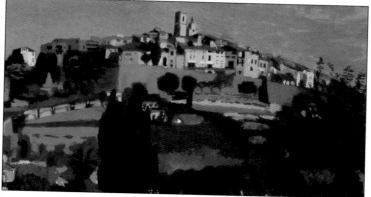

ST. PAUL DE VENICE by Jeremy Galton
This delightful painting of a hilltop village in the South of France also has a powerful sense of place, derived not only from the typical style of the buildings but also from the colors—deep, rich greens, ochres, and whites. The painting is a small one, done on mountboard, with the paints used very much as oil paints.

Perspective

To paint buildings and urban scenes successfully, you need to understand the basics of linear perspective—our main means of creating the illusion of three dimensions on a two-dimensional surface. Linear perspective is based on the observation that parallel lines on a receding plane, such as the tops and bottoms of windows, appear to converge.

If the parallel lines were to be extended, they would meet at a point known as the vanishing point (VP). The location of this point is dictated by your viewpoint, because it lies on a notional line called the horizon, which is at your own eye level. Thus if you are looking down at a town, perhaps from a hill, the horizon will be higher than the buildings, and the parallels will slope upward. If you are looking up at a tall building, the horizon will be low, and the lines will slope down.

Your angle of viewing does not alter the horizon, but it does affect the position of the vanishing point on the horizon. If you are directly in the middle of a street, the vanishing point will also be in the middle, opposite you, and the angle of the receding lines will be the same on both sides. But if you move to the right, the vanishing point will move with you, so the lines on the left will have farther to travel to the vanishing point than those on the right. You can see how this works in the drawings opposite.

Each separate plane has its own vanishing point, so if you are looking straight at the corner of a house, there will be two, and if a number of houses are set at different angles to one another, there will be several vanishing points.

Central vanishing point
The artist worked from a standing position, giving a horizon line roughly in the center of the picture. Because he is viewing from the middle of the street, the vanishing point is centrally placed.

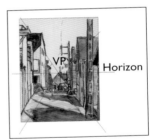

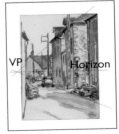

Changing the angle
The perspective alters when you move. The artist's eye level is the same in this view, so the horizon does not change, but he has moved to the right, and so has the vanishing point.

198

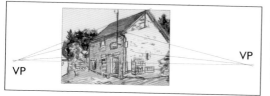

Separate vanishing points
This corner view of a house reveals two separate planes, each with its own vanishing point outside the picture area.

Inclined planes
The rule that the vanishing point is located on the horizon applies only to vertical or horizontal planes. Sloping planes, such as pitched roofs, have a vanishing point above the horizon. Houses set on a hill can be particularly confusing. The road going up- or downhill is an inclined or declined plane, and the vanishing point for the two sides is above or below the horizon. The houses themselves are built on level foundations, stepped up to accommodate the slope, and follow the normal rules.

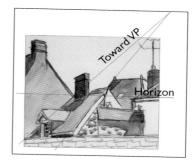

The lines formed by the edges of the roof converge only slightly. If they were extended, these lines would meet at a vanishing point well above the horizon.

Because the tops of the roofs slope slightly upward, we can tell that the town is hilly, with the artist's eye-level above the rooftops.

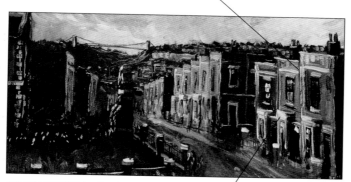

SOUTH STREET by Gerald Cains

These buildings run downhill. A line drawn through the center would meet at a vanishing point below the horizon (see Inclined planes, above).

PROPORTION AND CHARACTER

A knowledge of perspective will help you to make buildings look convincingly solid, but it will not enable you to express their particular character. For that, you need to train your own powers of observation. If you want to achieve a recognizable likeness, an attention to proportion and detail are crucial.

Before thinking about perspective, analyze your subject and decide what its special features are. Is the building unusually tall or wide? Are the windows large or small, close together or widely spaced, or deeply recessed in thick walls? Are there any wrought-iron balconies or carved lintels that will help you construct a portrait?

STYLES AND MATERIALS

Whether you are painting an urban or village scene, or an old barn set in a landscape, you will want to give the impression of a specific place. Building styles often vary distinctly from one country and region to another, and so do the materials used. The skyscrapers of Manhattan and the flat-roofed houses of Greek villages are two obvious examples, but there are numerous others, such as the dark red brick of Victorian London, clapboard houses in parts of the United States, gray or sand-colored stone cottages in Britain and Ireland, and tall glass and concrete structures in many modern cities.

Old buildings, in particular, can provide intriguing textures to exploit in your painting. Do not overlook the possibilities of old wood, crumbling brickwork, and peeling whitewash, because the texture of a building is an integral part of its character.

Fine linear brush strokes of light color were laid over brown to create the texture of the rusted corrugated iron.

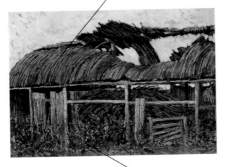

ATTENTION TO TEXTURE

Failing to exploit the rich textures of the wood and the rusted metal roof would have been a lost opportunity. They form an integral part of the subject, as exciting in their way as the dramatic shapes made by the broken roof outlined against the sky. The muted color scheme creates a somber atmosphere in keeping with the subject.

DERELICT BARN by Gerald Cains
The barn is the focal point of the painting, so the foreground is treated in less detail, with brush strokes suggesting grasses.

ATTENTION TO SHAPES

The small white or pastel-colored buildings set at seemingly random angles on a hillside are so typical of the Greek islands that little detail is needed, as long as the general shapes, proportions, and colors are correct. The artist paid careful attention to the shape of each house and the placing of the windows, and on the foreground wall gave a hint of the crumbly texture that is another feature of the whitewashed buildings.

ACROSS THE TOWN,
KEA
by Jill Mirza

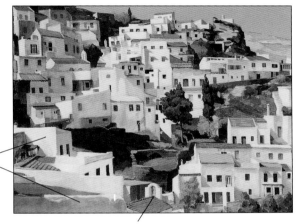

Thick walls are another characteristic of these houses, indicated here by the deep shadows.

The shape of this central building, with its upward-sloping wall, is clearly defined.

PAINT HANDLING TIP

There are various ways of suggesting the texture of brick or stonework. You can use broken-color methods, apply thick paint with a knife, or mix paint with another substance that imitates the texture. Special mediums are sold for texturing, but sand, chosen here, is equally effective.

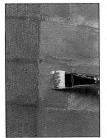

1 Begin with a base color in thinned paint. Then mix the color you want, add about half the quantity of sand, and apply it with a bristle brush.

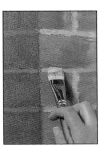

2 Use a little less sand for the lines of mortar between the bricks, because mortar has a smoother texture. Apply the paint with short, downward strokes.

INDIVIDUAL BUILDINGS

It is sometimes the hustle and bustle of a townscape, with people and cars, different colors, and the interaction of shapes provided by walls, rooftops, doors, and windows that provide the stimulus for a painting. But some buildings invite a closer, more portraitlike approach, either because they are beautiful in themselves or because they possess some striking quality of shape or texture.

If shape is the important element, as it is in Walter Garver's dramatic painting, you will obviously want to show the whole of the building, choosing the viewpoint that sets it off to best advantage, and perhaps simplifying or omitting other features in the scene. But texture, which can be one of the most attractive and painterly aspects of architectural subjects, can often be treated by taking a closer view and cropping in so that these surface qualities become virtually the subject of the painting.

Acrylic is particularly well suited to creating texture, either by brush or knife strokes, or by methods such as dry brush and scumbling.

OPENINGS 46-WOODEN HOUSE
by Nick Harris
Texture is the main preoccupation here, and it has been portrayed with skill. Working on watercolor paper, the artist has built up the painting in a layering technique, with a succession of thin washes.

WOMAN AND DARK DOORWAY
by Jill Mirza
Here the artist has taken a close view and made the texture of the flaking wall and the interplay of darks and lights the joint subjects of the painting. Working on canvas, she has used the paint both thick and thin, sometimes scumbling very thin colors over thicker applications.

THE TOURIST by Walter Garver

Industrial architecture, although it may lack the immediate appeal of old cottages and whitewashed Mediterranean houses, has its own fascination, and here the artist has made the most of the imposing shape of a grain elevator by taking a low viewpoint. The intensity and depth of color has been achieved by a series of transparent washes, one laid over the other to produce subtle blends and graduation.

THE RADCLIFFE CAMERA, OXFORD by Neil Watson

This famous building has been painted quite loosely and sketchily, and yet this is an excellent portrait because the proportions and major characteristics have been so well observed. To prevent any possibility of fading—there is a concern that some colored inks may not be lightfast—the whole picture was sealed with acrylic medium.

WINDOWS • ACRYLIC

1 Trying to paint straight edges is very difficult without the help of masking tape. In order to paint the window panes in this picture, the artist has used strips of masking tape.

2 If the tape is pressed down firmly and the paint is used quite thickly, clean edges should result. When the paint is dry, remove the tape carefully.

STREETS AND MARKETS

Unless you are painting portraits of individual buildings or a far-off view, people will nearly always form part of a town or village scene. Indeed, the daily ebb and flow of human beings going about their business is one of the attractions of such a setting.

Outdoor markets, cafés, and streets all make good subjects, particularly markets, as the stalls, with their colorful piles of produce, provide a fascinating array of shapes and textures.

Such paintings will usually have to be made from sketches, or from a combination of sketches and photographs, as people will not remain still long enough for you to complete a painting on the spot. This has the advantage of allowing you to compose the painting more thoughtfully and to use a variety of techniques. Mike Bernard, for example, has chosen collage for his exciting evocation of a bustling London market scene.

CHINATOWN by Gary Jeffrey

Full of life, color, and movement, this painting of London's Chinatown has been painted with bold, thick brush strokes on paper primed with shellac. The figures are treated with a minimum of detail—even the foreground figure has only the suggestion of facial features—but they are completely convincing because careful attention has been paid to their postures, clothes, and the way they move.

BANDSTAND STUDY III
by Judy Martin
This painting on paper, done from sketches, is one of a series in which the artist pushed an idea further and further toward abstraction. The subject initially attracted her because of her love of vivid colors.

FRUIT BOXES by Mike Bernard
Collage has been used with acrylic for this atmospheric market study, in which the figures form a generalized background to the strong geometric shapes. Notice how the collaged tissue paper, stuck to the hardboard support and painted over, forms a slightly crumpled texture—most clearly visible in the background.

The Animal World

To some degree, animal painting is a specialized branch of art. There are painters and illustrators who make it their primary field, often as the result of a deep fascination with wildlife—some wildlife painters are also qualified zoologists or ornithologists who spend long hours observing and photographing their subjects before painting them.

But while it takes considerable skill, experience, and practice to produce paintings of scientific value, correct in every detail, many fine artists, notably the French artists Théodore Géricault (1791–1824) and Edgar Degas (1834–1917), included animals in their repertoire, and there is no reason why you should not do the same. Both of these artists painted horses and jockeys—Géricault because he was a passionate horseman and Degas because he enjoyed the atmosphere of the racecourse and was fascinated by movement.

GATHERING INFORMATION

The main problem with animals is that they don't stay in one position for long, which makes it difficult or impossible to complete a painting in one session. There are exceptions, such as cats sleeping in the sun; sheep, which don't move far unless you frighten them; and cows lying or grazing in a field. But, in general, you should get into the habit of sketching animals so that you can work your

sketches up into a composition at home. You can also work from photographs, but this may give your painting a static quality unless you compensate by using the paint in an expressive and energetic way.

You can sketch in pencil or pen, but if you want information for a painting you will need color reference, too, so it is wise to use paints from the start. For speed, you could use thin washes of acrylic on paper, strengthened with pencil or charcoal (see Pencil and Acrylic pages 90–91, Charcoal and Acrylic pages 81–82). Apart from their value as references for painting, such sketches will help you become familiar with the forms and characteristic movements of animals, and may even turn out to be pleasing works in their own right.

TEXTURE

The texture of an animal's fur or hair is one of its most pleasing qualities, and acrylic is highly suitable for rendering a wide range of textures, from the sheen of a well-kept horse to the shaggy coats of some dogs. You can use blending techniques or directional brush strokes of thick paint; you can build up textures with dry brush techniques or scumbling; or you can combine paint with other media. Pastel and acrylic, for example, is ideal for textures and also helps to impart a lively feeling to the image.

PAST THE POST
by Robert Burkall Marsh

Movement is wonderfully well suggested in this painting by the loose brushwork used for both the sky and the horse and jockey. The composition also plays a part in the depiction of movement; the way the horse's body has been cropped on the left seems to impel it forward, following the line of the jockey's back.

PEACEFUL WATERS by Michael Kitchen-Hurle

The swans' bodies against the dark grass form a pattern of light on dark, a theme carried right through the painting by the inclusion of the white flowers on the left and the dark foliage at the top right. The latter is also important for its role in explaining the dappled shadow cast on the birds' plumage and the points of light on the grass.

ENVIRONMENT

If you are sketching animals for practice, you need not worry about the setting, but in a finished painting you will usually want to show the creature in its characteristic environment, whether domestic interior, garden, farm building, or landscape. When making sketches for a finished painting, try to give yourself sufficient information about the setting—you might make separate studies of any feature that will play a part in the composition.

The way you treat the setting depends on your overall approach. It is vital to marry the two elements of the painting, so if you intend to portray the animal in a broad, impressionistic manner, don't introduce too much detail into the surroundings—you may be able simply to suggest them with a few brush strokes. If you prefer a more descriptive approach to your subject, the setting must be painted with equal attention to detail, as in Michael Kitchen-Hurle's delightful painting of a fox (opposite).

EVENING LIGHT by Bart O'Farrell
A more detailed approach has been taken to both the animals and their landscape setting in this tranquil painting, but the evening light silhouetting the forms has allowed for a degree of simplification. The painting surface is muslin stuck onto hardboard, and the paint has been used thinly enough for the texture to be clearly visible.

SLEEPING IT OFF by Michael Kitchen-Hurle
This beautifully painted study is reminiscent of Victorian watercolors in its delight in detail and texture. The fox's fur and the grass have been built up in a series of tiny brush strokes of medium-thick paint, while transparent washes have been used for the shadows on the cart.

GILGIT by Helena Greene
In this exciting painting on watercolor paper, detail has been kept to a minimum in order to express fully the all-important sense of movement. Although polo players and background are treated with no more than a few bold brush strokes, their actions and positions are so well observed that they carry complete conviction.

BIRDS AND FISH

Birds and fish may present special problems, as they cannot usually be sketched in their natural surroundings. There are notable exceptions—such as geese, ducks, and swans on lakes and ponds, or garden birds feeding from a bird table, all of which make attractive subjects—but for fish or birds in the wild, you may have to rely mainly on photographic reference. There is nothing wrong with this—most wildlife artists make use of the camera—but it is important to observe the subject carefully as well as photograph it, or your paintings will lack the firsthand experience that gives them feeling and authenticity.

In order to familiarize yourself with the structure, colors, and plumage of birds, and the shapes and forms of fish, you could also try making studies from museum exhibits or consulting the drawings and paintings in natural-history books and magazines. The latter will also provide information on habitat.

OVER THE SHALLOWS—PIKE by Richard J. Smith
Smith is a professional wildlife artist, and his paintings are evidence of how thoroughly he has observed his animal subjects and their habitats. The painting is on hardboard, primed with acrylic gesso to provide a smooth surface, and the paint has been diluted with gloss medium. The effect of the water surface reflecting light was achieved by brushing a thinned blue-white glaze over the surface with single strokes of a large household paintbrush.

TRAFALGAR SQUARE by Richard J Smith
A primed hardboard panel was also used for this painting, but here the colors were thinned with matte medium rather than gloss. Relatively thick paint has been used for the plumage of the birds—notice the individual brush strokes of white and near-black on a thinner, midtoned underpainting. The puddles have been built up in a series of glazes, opaque in the center and becoming more transparent toward the edges.

FEATHERS

In most birds, the wing and tail feathers are quite smooth and precise in shape, while the neck and throat feathers have a downy quality. Begin by painting the bird with a pale underwash. Then use a small, soft brush to delineate the markings of the main feathers, working wet over dry to achieve a precise pattern. The soft, downy feathers should be added last, using light, scumbled strokes.

FEATHERS • GOUACHE

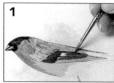

1 Once the washes of base color have dried, you can start adding details to the plumage, gradually building up the color and texture. The artist here has used a very dry brush with the occasional touch of liquid paint to emphasize the changes in tone and to bring vitality to the image.

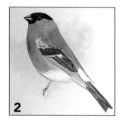

2 The vivid colors of the breast feathers are added in crimson and cadmium red. The texture of the feathers on the back is built up in tones of gray, using a fine sable brush.

3 Stroke by stroke, the artist creates the fine texture of the back feathers. Highlights have been added using white paint, and here he is adding darker tones using a No. 0 sable brush.

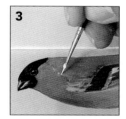

4 Using a very small sable brush, the artist paints fine, parallel strokes in dry, undiluted paint to add the final touches to the plumage. This hatching technique is particularly good for conveying the texture of feathers.

5 In this detail, you can see the wide range of tones used, and the careful hatching and cross-hatching of the strokes.

CAT STEP-BY-STEP

The basis for this composition by Judy Martin was a black-and-white photograph, which allowed the artist freedom over the choice of colors. As a long-time cat owner, she is familiar with feline subjects, and has studied and sketched her own cats extensively.

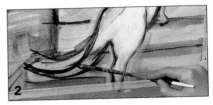

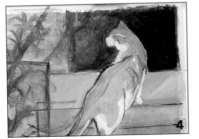

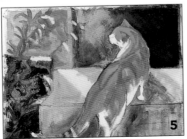

1 Working on watercolor paper, the artist begins with a brush drawing to establish the placing of the cat; the emphasis is on strong curves sweeping diagonally across the center of the picture.

2 A monochrome underpainting is made next. At this stage, the drawing is amended by bringing the tail lower down and placing masking tape across the bottom of the picture to give a tighter crop. Previously, the leg had been cropped just above the foot, which looked awkward.

3 This vertical line is important, as it provides a balance for the diagonal formed by the body of the cat, so an edge of paper is used as a ruler to ensure that the line is straight.

4 The first colors are now laid over the underpainting. The orange provides a key for the painting, but it will be modified as the work progresses.

5 The colors of the cat are now built up more richly, beginning to define the forms of the animal, and grays

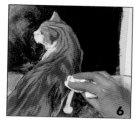

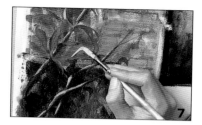

and yellows have been lightly scumbled over the wall. This same broken-color effect has been applied to the background, contrasting with the crisper painting of the animal's head.

6 The markings and texture of the cat's fur have been accurately depicted by a combination of dry brush and lightly applied wetter paint. Further modeling is now given to the animal's body, with a rag used to push the dark paint into place and hold it away from the white area.

7 With the cat completed, the artist can now assess how much detail and definition is required elsewhere in the painting. Thick, light-colored paint is applied with a nylon brush to create highlights on the leaves and branches.

FINISHED PICTURE

The definition of the left-hand side of the painting plays an important part in the

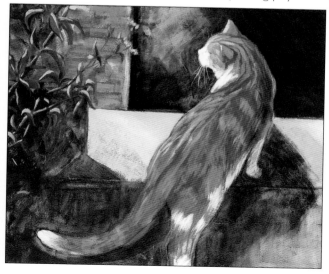

composition, as a focus is needed in the direction of the animal's gaze. The dark and light rectangles are equally vital in compositional terms, providing a geometric framework for the long curves of the body and tail.

Portrait and Figure Work

The primary task of a portrait is to produce a likeness of the sitter, but it doesn't end there, because a portrait is a painting as well, and to succeed in terms of art it must meet the usual criteria of composition, balanced color, and successful rendering of three-dimensional form.

Even if you are painting a head-and-shoulders portrait, where you don't have a variety of elements to juggle with, you must consider composition, deciding what angle to paint the head from, where to crop off the body, and how much space to allow above the head. For a three-quarter or full-length figure, you will usually have to include some of the room, though a common convention for standing figures is to leave the background vague to prevent it from competing with the figure.

If you choose to make the setting a part of the composition, you have the advantage of being able to provide visual clues about your sitter's interests. A portrait is not just a description of features; it should convey something of the character and atmosphere of the person as well.

It is usually taken for granted that portraits are painted indoors, but they don't have to be. Someone who leads a mainly outdoor life, such as a farmer, a gardener, or a landscape painter who works out-of-doors could be painted in this natural setting, with the portrait treated in a more informal manner. Artists who habitually work together often paint each other in this way, and often produce a convincing likeness when the face is not even visible, simply by accurate memory.

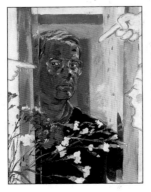

SELF PORTRAIT by Gerry Baptist
The hands and head at the top and right side of this unusual self portrait on canvas board (left) represent an audience—the viewers of the painting process. Most portrait painters are familiar with the experience of would-be helpful remarks made as they work, and here the artist has "painted" in the comments, bringing the viewer into the portrait.

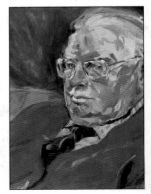

JEAN'S FATHER by Gerry Baptist
In this portrait on canvas board, the artist has used a traditional compositional arrangement, cropping the head on the right and thus allowing more space in the direction of the sitter's gaze.

GIRL READING by Ted Gould

Children are not the easiest of portrait subjects, but they can often be painted in short sessions when absorbed by some favorite activity, as in this charming study. The artist has worked on canvas board, starting with a thin underpainting and building up gradually to thick impasto. He uses retarding medium to enable him to manipulate the paint for a longer period.

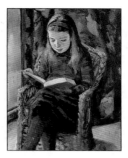

THE SETTING

The setting depends upon the kind of portrait you intend to paint. There are three main types: a head and shoulders; a half-length, which includes the body down to the hands; and a full-length, showing the whole body, either seated or standing. The setting is unimportant for the first sort, because all you will see is an area of space around the sitter's head. You can adopt the same approach for half- or full-length portraits, leaving the background vaguely suggested, but you could use the opportunity to add some information by painting the sitter at home or at work, surrounded by personal objects.

The perspective is slightly distorted, as it might be in a photograph, so that the side of the fireplace echoes the diagonal slope of the figure.

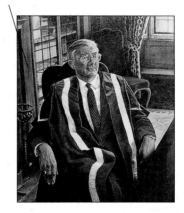

The smile affects the entire face, not just the mouth.

The broad brush strokes and lack of detail testify to the rapidity of execution.

COMPOSING A PORTRAIT

The two main technical tasks of the portrait painter are to achieve a likeness and to make the forms appear solid and three-dimensional. Neither of these is easy, which often causes beginners to forget that a portrait also requires a structured composition. If you are painting a head-and-shoulders portrait, you may think it does not need to be composed because there is only one element to deal with—but it does. You must decide upon your angle of viewing, how you will place the head, how much space you will leave around it, and at what point you will cut off the body.

VIEWPOINT AND COMPOSITION

The golden rule of avoiding symmetry applies as much to portraiture as to any other branch of painting, though it can be broken on occasion: a symmetrically placed head seen from directly in front can give a powerful feeling of confrontation. A profile does the opposite. It can present an excellent likeness, but it will engage the viewer because the subject is looking out of the picture. Many portraits show a three-quarter view, with the eyes looking out. This angle has the advantage of breaking the symmetry because the shoulders are seen at a slant, with one higher than the other.

Where you cut off the body in a head-and-shoulders portrait depends to some extent upon the sitter's clothing. The traditional cutoff point is just below the neck. But if the sitter is wearing an open-necked shirt, or a low-cut V neckline, the best cutoff point would be immediately below the opening, not in the middle of it, which could give the impression of the head and neck being arbitrarily chopped off. Half-length portraits usually show the body down to the hands.

The pose, with head resting on hand, combines with the quiet color scheme to give a pensive atmosphere to the painting.

The hand was only lightly suggested, because a detail here would steal attention from the face.

PLACING THE FIGURE

This shows a conventional and always pleasing compositional structure for a half-length portrait, with the body placed to one side and viewed from a three-quarter angle. The chair was cropped on the left, and the body framed just below the hand.

MODEL AT ALSTON HALL COLLEGE
by Nolan Abbott

LIGHTING A PORTRAIT

When you are setting the pose for a head-and-shoulders portrait, consider the direction and intensity of the light, both of which play an important role. Soft side or three-quarter lighting are favored choices, because they create areas of highlight and shadow that model the forms well. Direct front lighting is usually less satisfactory. You can use natural or artificial light, but take care that the latter is not too harsh. Strong light creates dramatic effects, but these would be unsuitable for portraits of young people or children. If side lighting makes the shadows too dark, prop up a piece of white cardboard on the dark side to reflect some of the light.

PORTRAIT MODELING

A portrait that focuses on the head is easier to compose than a full-length or half-length view because there is only one main element to consider. You must think about the placing of the head, the angle of viewing, and the lighting, which plays a vital role in modeling the forms. The term modeling refers to the process of recreating three-dimensional form—the painter's equivalent of what the sculptor does with solid materials. For this picture, the artist chose a way of lighting that is often used in portraiture, coming from one side and slightly in front of the sitter, throwing a quarter of the face into shadow and creating strong

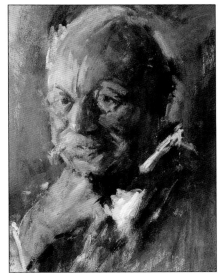

MAN WITH MOUSTACHE by Ken Paine

gradations of tone and color. The rough execution of the finished painting, with its expressive brushwork, contributes to the vigorous character of the portrait.

For the portrait of a child, you would not normally want hard shadows and obvious gradations of tone, but strong light gives dramatic emphasis, and can be a good choice for a painting of an older person. Here the chiaroscuro (light/dark) effect focuses attention on the face. The white collar and the hand both play a significant part in the composition: The white of the collar provides a tonal balance for the gray-white moustache and hair, while the hand leads the viewer's eye up to the face.

FIGURE GROUPS

Once you are confident in drawing and painting individual figures, it is a small step to composing groups. Your priorities here will be somewhat different, however, because you must consider not only how to make each figure convincing but also how to cope in compositional terms with the interactions between the figures. Groups of people usually have a reason for being together. They may be sharing an activity or simply be linked by being in the same place—perhaps shopping or standing in line for a bus.

You can express these unseen links by creating visual ones, such as a figure leaning across or toward another, or the arm of one person overlapping the body of another.

Paintings of figure groups usually have to be done from sketches, though photographs can also provide ideas for paintings. If you have made drawings in a life class or sketches of people out-of-doors, you might try some initial experiments with these, putting them together in different ways until a composition begins to emerge.

SKETCHING FOR FIGURE GROUPS

Paintings of figure groups are often done from sketches, partly because people seldom stay still long enough to be painted on the spot, and partly because the composition requires careful planning. You can compose groups from sketches of individual people provided your drawings convey enough visual information; you need to relate the figures to each other and to the setting. Give an indication of scale by sketching in a little of the background and surroundings— a café table, a beach umbrella, a building. Indicate any shadows, so that you know the direction of the light, and make notes about colors.

In this composite pencil and watercolor sketch, with superimposed figures, the artist focused on expressive gesture.

The table and shopping bags give context to the rapidly sketched figures. Light watercolor washes provide the color information.

GROUP DYNAMICS

Any group of figures will have something in common. Several people walking down a street, strangers to one another, will share the same setting and the same weather conditions. A group of children building sandcastles or a family enjoying a picnic will be linked by a communal activity. These are narrative links, to achieve a coherent composition, pictorial ones are needed, also. To avoid isolating a figure, you can let another one overlap it. Spatial relationships can be

suggested by allowing the arm or leg of a foreground figure to cut across the body of another one behind. If figures are separated by space, link them by repeating colors. The red of a garment, say, could be introduced in small quantities in the clothes of other figures. Shadows can form a bridge between figures, leading the eye from one to another.

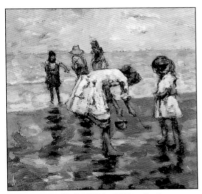

THE SAND PLAYERS by W. Joe Innis

PICTORIAL LINKS

This composition is artfully planned so that the figures are linked both to each other and to the surroundings by repeated colors and overlapping shapes. Notice, also, how well the shapes and tones are balanced, with the bending figure forming a horizontal light-toned shape that cuts across the darker verticals of those behind.

NARRATIVE ELEMENTS

These figures are linked through their shared conversation and environment. But there are pictorial connections also, with the device of overlapping used to bond the group and explain both spatial relationships and the relative sizes of the figures.

AND FAR AWAY THE SILENCE WAS MINE by David Carpanini

THE FISH MARKET by Robert Burkall Marsh
Here the figures are linked by a common purpose—the purchase of fish. The painting is full of movement, with the eye led around the composition from the diagonal slant of the fish to the arms and faces of the figures. Although the color scheme is muted—almost monochromatic except for the dash of orange—the strong light-dark contrasts create a feeling of vitality.

Glossary

Abstract Expressionism A school of painting based on the expression of the subconscious.

Acrylic A comparatively new paint in which pigment is suspended in a synthetic resin. It is quick-drying, permanent, and colorfast.

Acrylic Gesso An acrylic primer that gives a bright white surface for painting on. Nothing to do with real gesso.

Alkyds A type of acrylic paint that is soluble in turpentine instead of water.

Alla Prima Direct painting in which the picture is completed in one session without any underpainting or underdrawing.

Bleeding The effect created by wet color that runs.

Blending Merging colors together in such a way that the joins are imperceptible.

Blocking In The initial stage of a painting when the main forms and composition are laid down in approximate areas of color and tone.

Chiaroscuro The use of light and shadow to create form in a painting.

Classic Method A painting technique that involves making a monochrome under-painting before adding color.

Composition Arranging and combining different elements to make a picture.

Covering The covering power of a paint refers to its opacity.

Cross-hatching A method of building up areas of shadow with layers of crisscrossed lines rather than with solid tone.

Fixative Thin varnish that is sprayed on drawing media, especially charcoal and pastel, to prevent smudging.

Flow Improver A product that can be added to acrylic color to make the paint easier to spread.

Fresco A wall-painting technique usually done with watercolor on damp plaster.

Glazing Using a transparent film of color over another pigment.

Golden Section A geometric proportion used by artists since Classical times, and thought to produce the most harmonious composition.

Gouache An opaque watercolor similar to poster paint.

Graphite A carbon that is used with clay in the manufacture of lead pencils.

Hatching A shading technique that uses parallel lines instead of solid tone.

Impasto The thick application of paint or pastel to the picture surface in order to create texture.

Impressionism A painting style founded in France during the late nineteenth century that aimed at a naturalistic approach by depicting the atmospheric effect of light using broken color.

Local Color The actual color of the surface of an object without modification by light, shade, or distance.

Masking The principle of blocking out areas of a painting to retain the color of the support. This is usually done with tape or masking fluid.

Medium In a general sense, a medium is the type of material used.

Monochrome A painting done in black and white and one other color.

Negative Space The space around the subject, formed by drawing or painting

around the object rather than the object itself.

Op Art Sometimes called optical art, this style of painting creates particular visual effects with optical illusions.

Opacity The ability of a pigment to cover and obscure the surface or color to which it is applied.

Optical Mixing Mixing color in the painting rather than on the palette, for example, using dabs of red and yellow to give the illusion of orange.

Painterly The use of color and light to create form rather than relying on outline.

Palette This term describes both the flat surface used by the artist to mix colors on and the color selection used by the artist.

Photorealism An ultrarealistic school of art, so called because the paintings often looked like photographs.

Pigment The coloring substance in paints and other artists' materials.

Planes The surface areas of the subject that can be seen in terms of light and shade.

Pop Art An art form that uses images and artifacts from mass media and advertising and other ephemera of contemporary, urban life.

Primary Colors In painting, these are red, blue, and yellow.

PVA Paints Colors mixed with polyvinyl acetate resin. These paints are cheaper than acrylics but share many of their advantages.

Realism An art form that takes its subject matter from everyday life.

Renaissance The cultural revival of Classical ideals that took place in Europe from the fourteenth to the sixteenth century.

Render To draw or reproduce an image.

Retarder A transparent medium used to slow down the drying time of paints.

Sepia A brown pigment traditionally made from the ink of the octopus.

Staywet Palette A special palette, designed for use with acrylic paint, that keeps the paint moist for several hours.

Stencil A piece of cardboard or other material out of which patterns have been cut. The pattern or motif is made by painting a surface through the hole.

Still Life A picture of mainly inanimate objects.

Staining Using diluted color directly on unprimed canvas or cotton.

Stipple A method of painting, drawing, or engraving using dots instead of lines.

Support A surface for painting on, usually canvas, board, or paper.

Underdrawing The preliminary drawing for a painting, often done in pencil, charcoal, or paint.

Underpainting The preliminary blocking-in of the basic colors, the structure of a painting, and its tonal values.

Vinyl Paints Cheap, plastic-based paints, marketed in large quantities and made specially for use on large areas.

Wash An application of thin color, diluted to make it spread transparently and thinly.

Wet-into-Wet The application of watercolor to a surface that is still wet, to create a subtle blending of color.

Wet into Dry The application of watercolor to a completely dry surface, causing the sharp, overlapping shapes to create the impression of structured form.

Index

Picture Credits

The material in this book previously appeared in:

The Encyclopedia of Acrylic Techniques; Acrylic Decorative Painting Techniques; Painting with Acrylics; Acrylic School; The Complete Drawing and Painting Course; An Introduction to Painting with Acrylics; The Complete Artist; The Artists Manual;The Encyclopedia of Illustration Techniques;The Encyclopedia of Watercolor Landscape Techniques; Practical Watercolor Techniques; Watercolor School; The Illustrated Book of Painting Techniques; How to Draw and Paint in Watercolor and Gouache; The Complete Watercolor Artist; The Encyclopedia of Flower Painting Techniques.